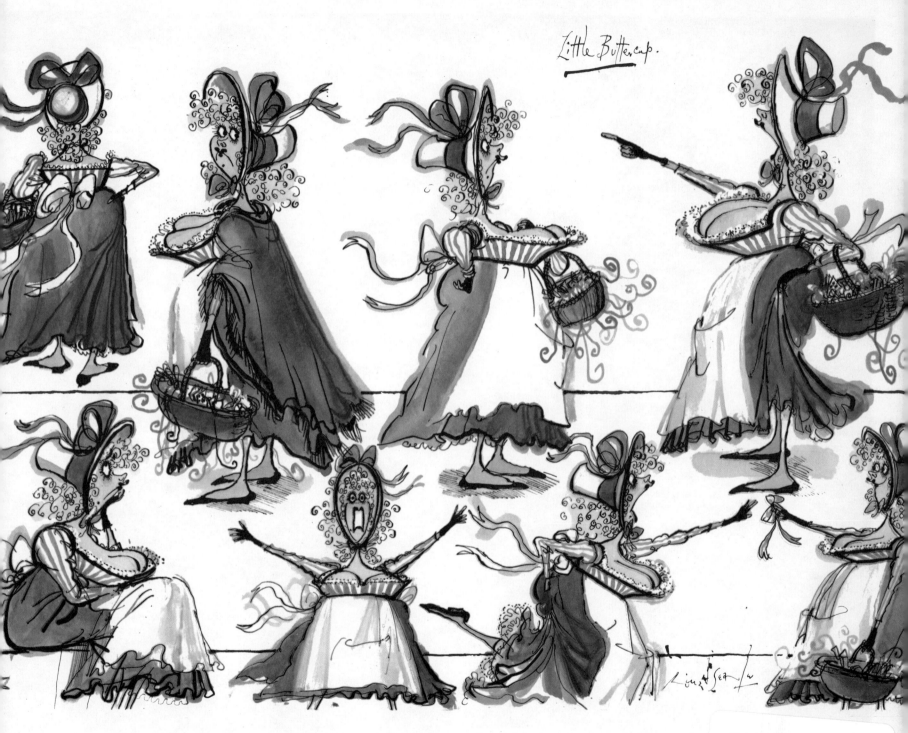

Little Buttercup.

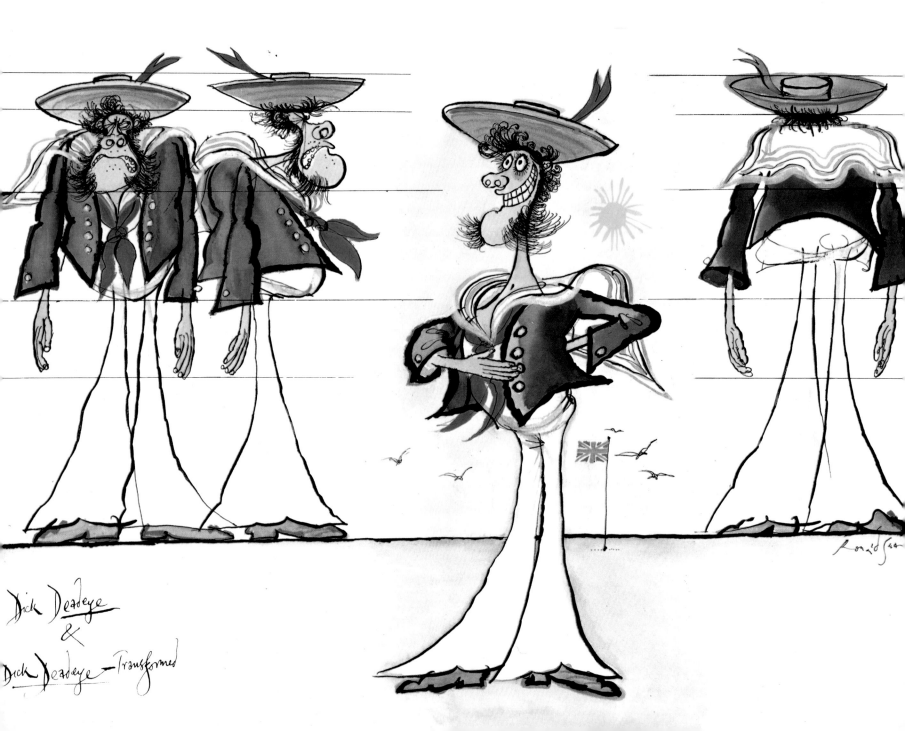

Dick Deadeye
&
Dick Deadeye – Transformed

DICK DEADEYE

based on the drawings of *Ronald Searle* and the operas of *Gilbert & Sullivan*

character drawings from the film 'Dick Deadeye or Duty Done' by Bill Melendez Productions

Jonathan Cape Thirty Bedford Square London

Edited and Designed by Derek Birdsall
Original story by Leo Rost
Additional lyrics by Robin Miller
Text: Jeremy Hornsby
Layout: Zoë Henderson

Printed in Great Britain

Library of Congress Cataloging in Publication Data

Searle, Ronald, 1920–
Dick Deadeye.

Based on an animated motion picture for which Searle
produced artwork for Gilbert and Sullivan characters.
1. Searle, Ronald, 1920– I. Gilbert, Sir
William Schwenck, 1836–1911. II. Sullivan, Sir Arthur
Seymour, 1842–1900. III. Title.
NC1766.G72S42 741.59'42 74–8141
ISBN 0–15–125600–4

First American edition

B C D E

Dick Deadeye:	A monocular matelot, who does nothing if not fast. A Zippie. A Streaker. He has a mean mien, and also is unpleasant to behold.
John Wellington Wells:	A rather silly Sorcerer, who has difficulties in spelling. He could be a confidence trickster, if only he had the confidence. Appears in many guises and disguises.
Schlameleon:	The Sorcerer's sidekick. A multi-coloured mammal. A misfit.
Buttercup:	One . . . no, two . . . of Nature's boobs. A buttoneer.
Major-General:	A minor general. A mixture of vanity and insanity. Leads his troops from the rear.
Admiral:	A Commander of the Bath. A navel type who prefers to regard his feet and his toes, rather than his fleet and his foes.
Relatives:	(Cousins, aunts etc) Relatives. (Cousins, aunts etc) What else can one say?
Captain:	An operatic mariner, who is unwilling to hit the High C's. Thinks hatches have to do with chickens. *He* is chicken.
Rose Maybud:	A lady(sic) of promiscuous proclivities, which barely confine themselves to her corset. Interested in sin.
Nanki:	A split personality.
Poo:	A personality split.
Nanki-Poo:	You figure it out.
Judge:	A man who climbed the judicial tree by hard graft. His only tennis shots are backhanders, and he will only sail with a jury rig. To him, summing-up means counting his bank balance.
Queen:	A hand waving from a carriage.
Zara:	An available Princess. Eligible and illegible.
Zara's Ladies:	Tropical Island 'hostesses'.
Pirate King:	A villain. A monodextrous marauder. Talks double-dutch, which is why he is known to his friends as the Hook of Holland.
Pirates:	Losers. The Pirate King's henchmen and wenchmen.
Yum Yum:	A delectable, but barely detectable, Eastern Delight. A fantasy, who appears when Nanki plays with his *Sami Sen*.
Balloon:	A prop. (Short-lived).

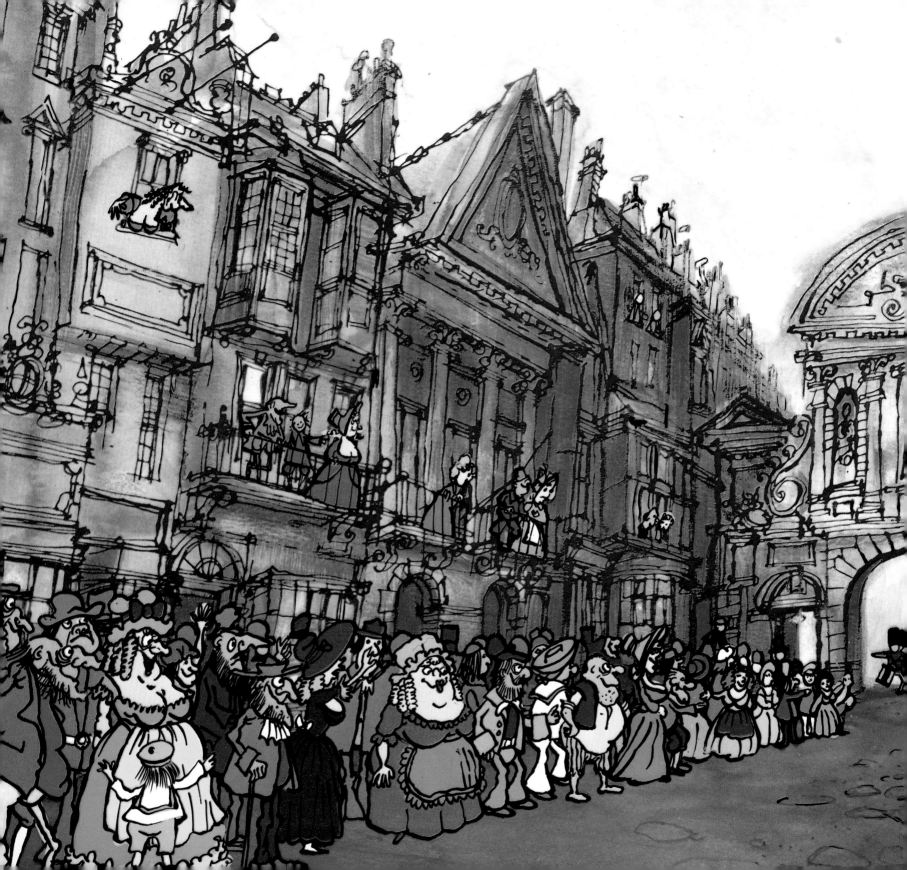

This Tale (*like This Book*) starts to unfold at a Parade,

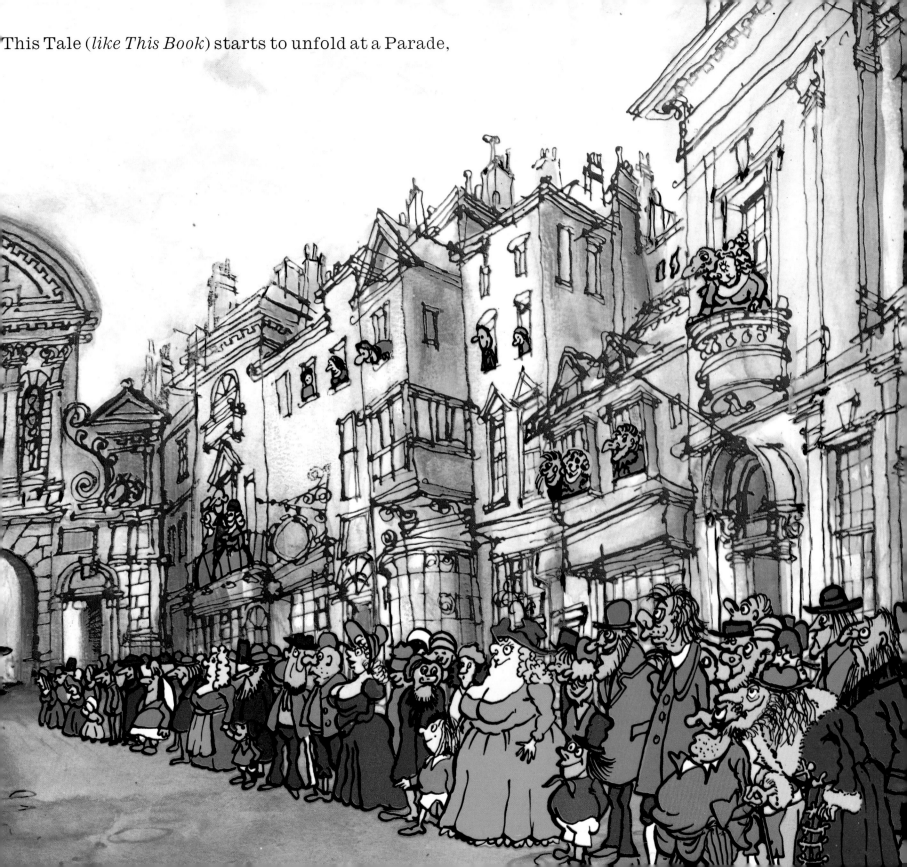

during which the **Manual Monarch** and her obsequious subjects wave back and forth.

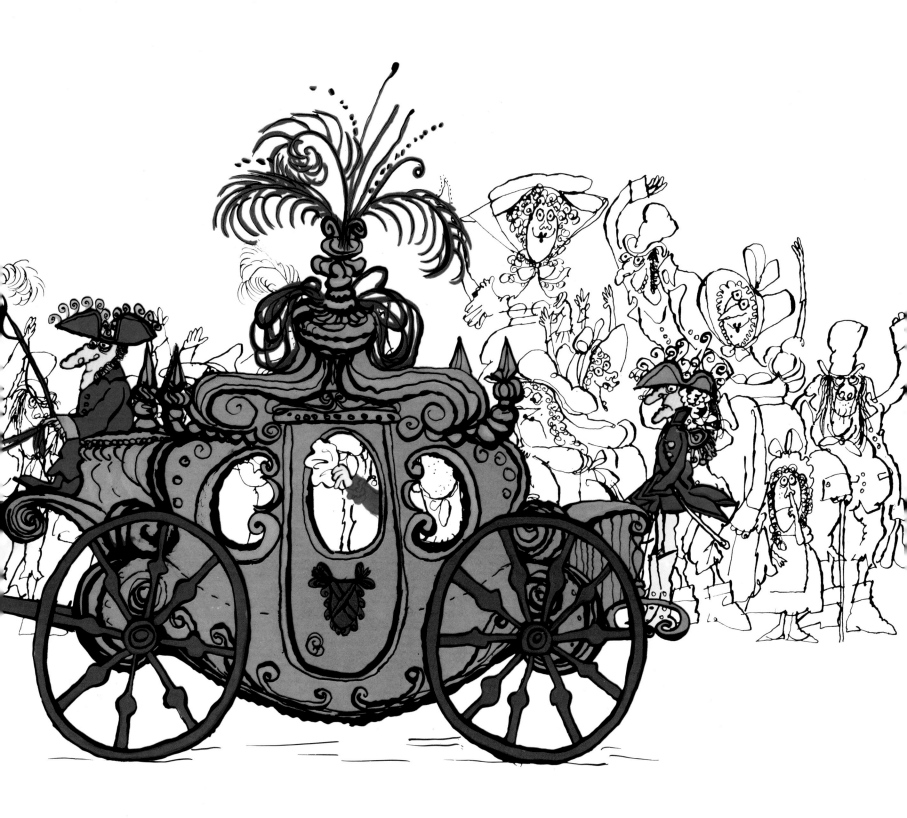

During this waving, one POO picks pockets, observed by his disapproving brother, NANKI. Elsewhere a **Sorcerer** has also been relieving the gullible citizenry of their assets, using Various Devices.

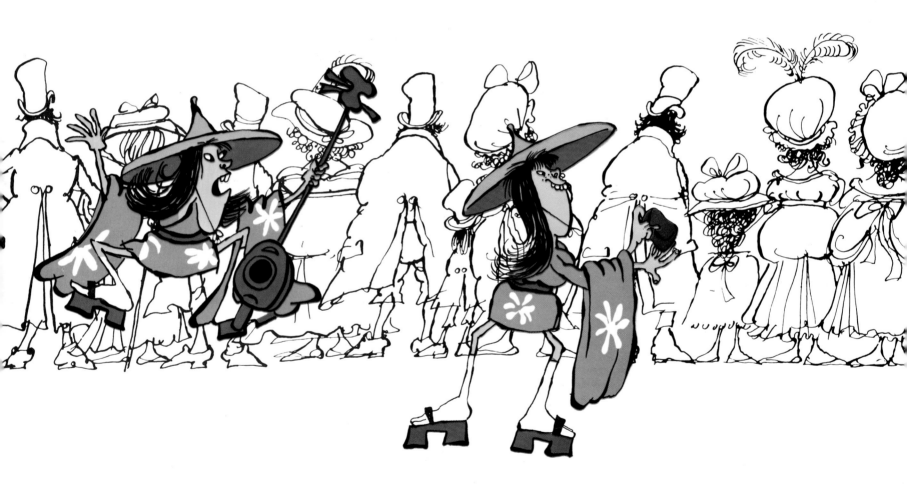

The Sorcerer confers with a nearby Pirate King, allowing our plot to thicken. He reveals that he has **The Ultimate Secret** to sell. But ALL IS NOT LOST! *Our Hero*, Dick Deadeye, has been dropping some eaves.

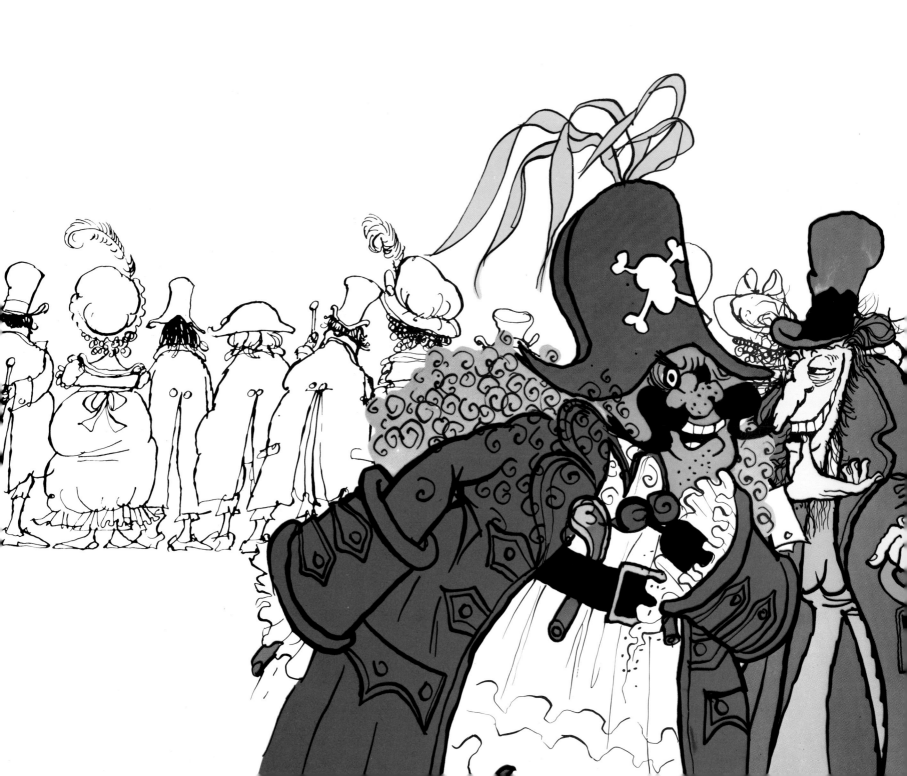

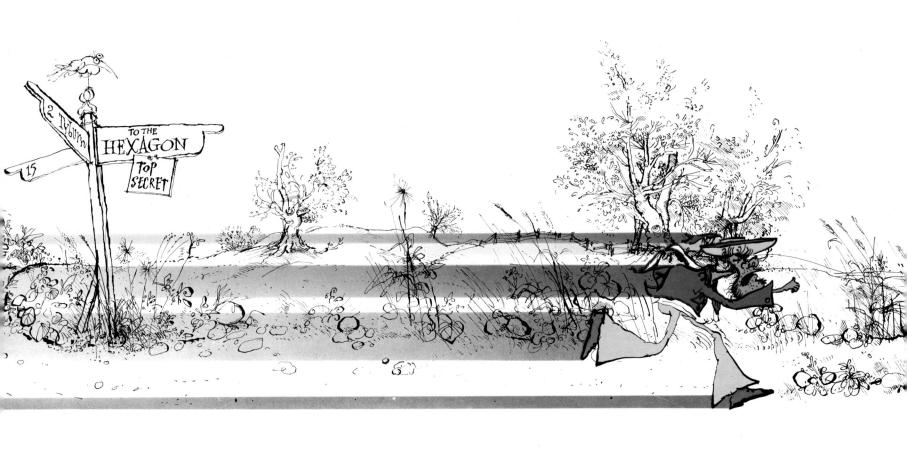

Quickly realising that Trouble is Afoot, Dick streaks to the **Hexagon** . . .

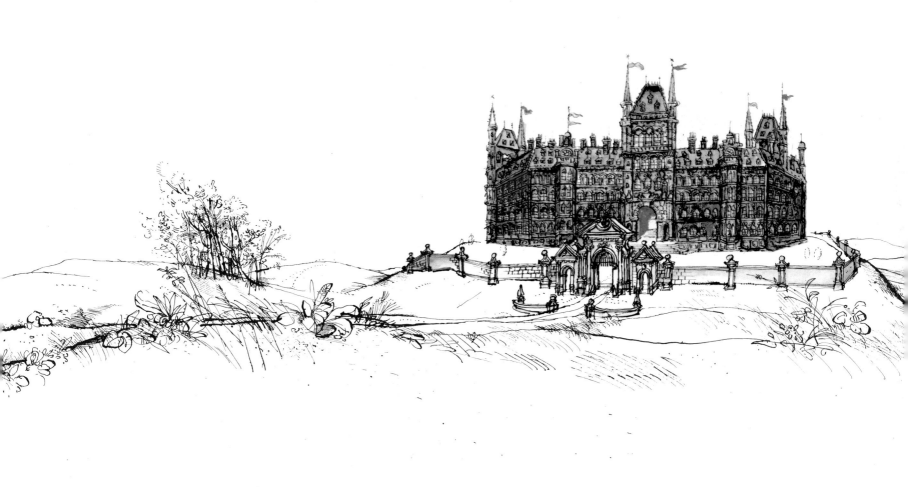

. . within whose warlike walls he finds some corridors along which to power. Outside a Major-General's Office, he convinces an *unconvincing Captain* that he is on an errand of **import.**

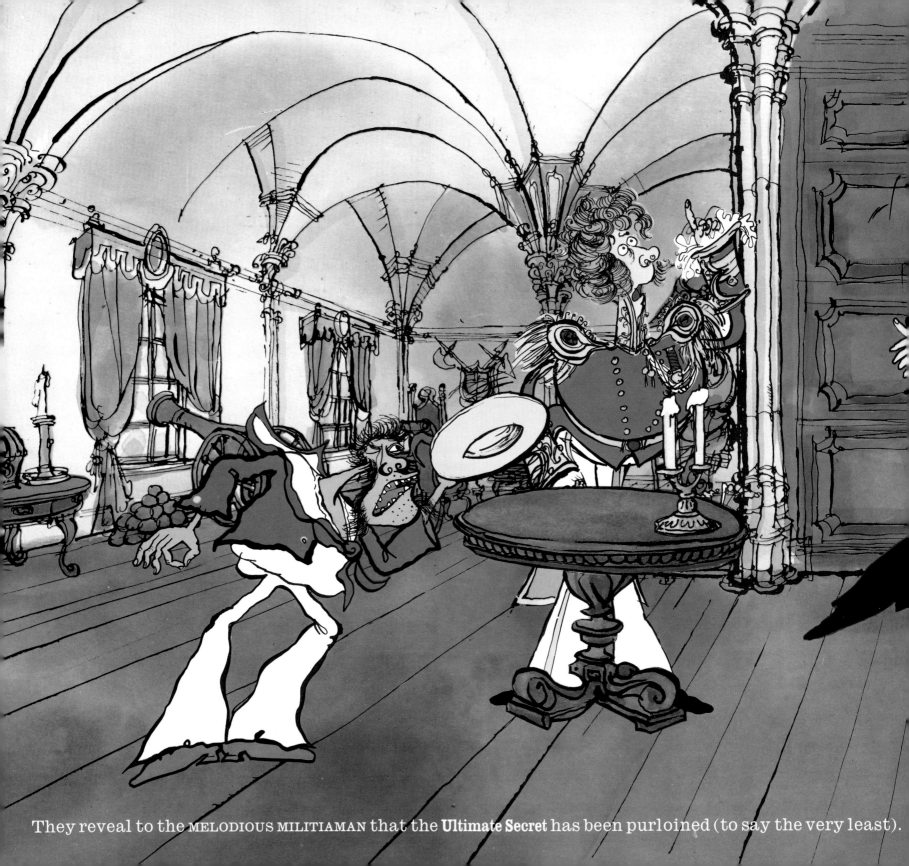

They reveal to the MELODIOUS MILITIAMAN that the **Ultimate Secret** has been purloined (to say the very least).

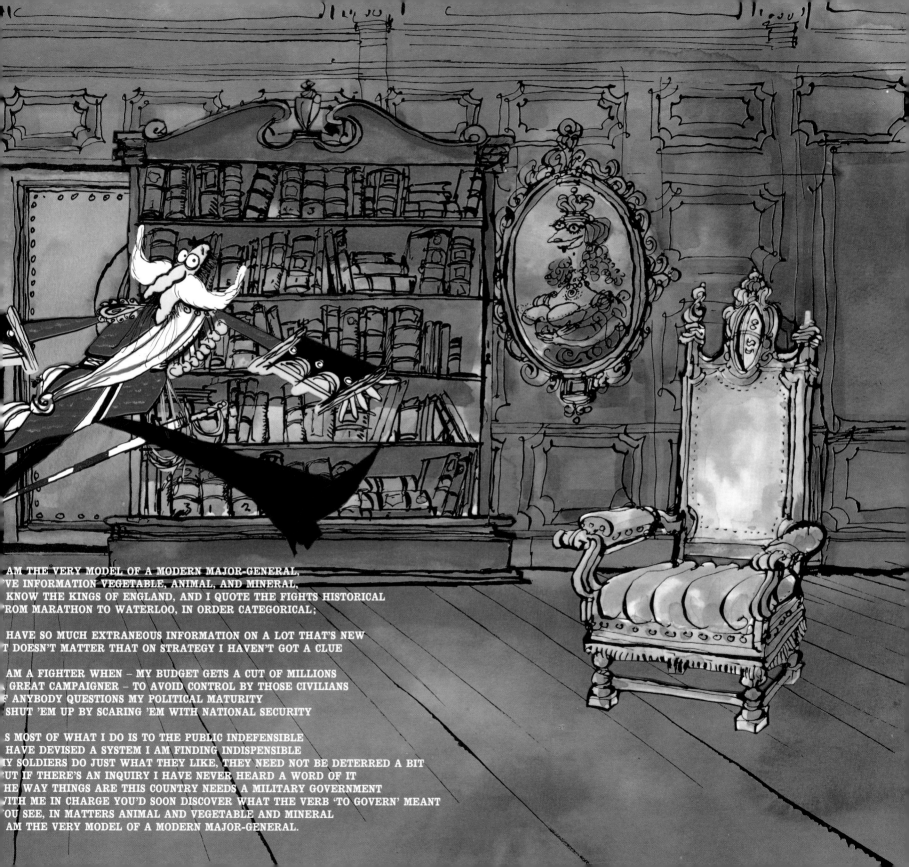

AM THE VERY MODEL OF A MODERN MAJOR-GENERAL,
'VE INFORMATION VEGETABLE, ANIMAL, AND MINERAL,
KNOW THE KINGS OF ENGLAND, AND I QUOTE THE FIGHTS HISTORICAL
ROM MARATHON TO WATERLOO, IN ORDER CATEGORICAL;

HAVE SO MUCH EXTRANEOUS INFORMATION ON A LOT THAT'S NEW
T DOESN'T MATTER THAT ON STRATEGY I HAVEN'T GOT A CLUE

AM A FIGHTER WHEN – MY BUDGET GETS A CUT OF MILLIONS
GREAT CAMPAIGNER – TO AVOID CONTROL BY THOSE CIVILIANS
ANYBODY QUESTIONS MY POLITICAL MATURITY
SHUT 'EM UP BY SCARING 'EM WITH NATIONAL SECURITY

S MOST OF WHAT I DO IS TO THE PUBLIC INDEFENSIBLE
HAVE DEVISED A SYSTEM I AM FINDING INDISPENSIBLE
IY SOLDIERS DO JUST WHAT THEY LIKE, THEY NEED NOT BE DETERRED A BIT
UT IF THERE'S AN INQUIRY I HAVE NEVER HEARD A WORD OF IT
HE WAY THINGS ARE THIS COUNTRY NEEDS A MILITARY GOVERNMENT
ITH ME IN CHARGE YOU'D SOON DISCOVER WHAT THE VERB 'TO GOVERN' MEANT
OU SEE, IN MATTERS ANIMAL AND VEGETABLE AND MINERAL
AM THE VERY MODEL OF A MODERN MAJOR-GENERAL.

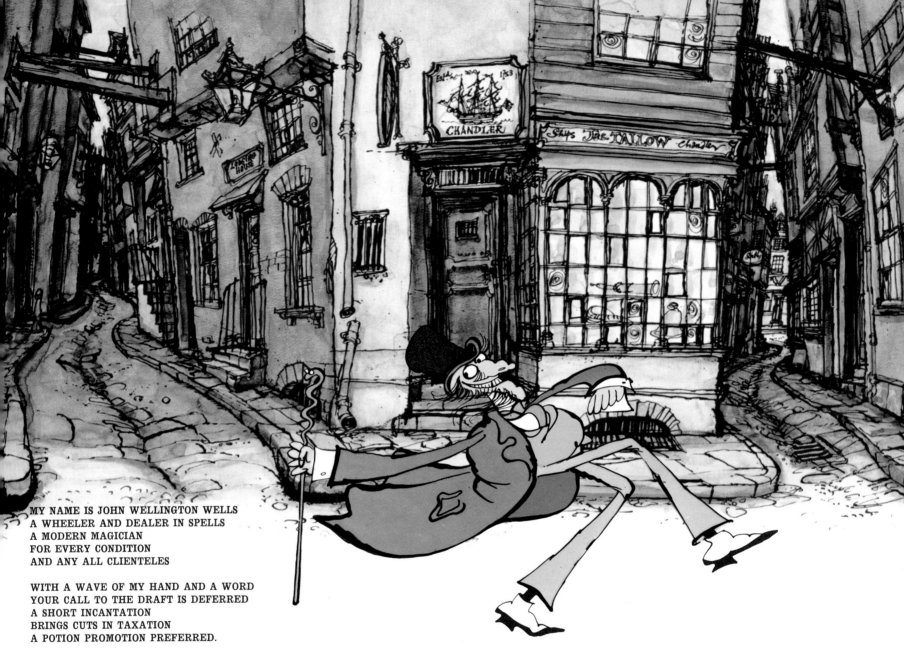

MY NAME IS JOHN WELLINGTON WELLS
A WHEELER AND DEALER IN SPELLS
A MODERN MAGICIAN
FOR EVERY CONDITION
AND ANY ALL CLIENTELES

WITH A WAVE OF MY HAND AND A WORD
YOUR CALL TO THE DRAFT IS DEFERRED
A SHORT INCANTATION
BRINGS CUTS IN TAXATION
A POTION PROMOTION PREFERRED.

YOU ARE BOURGEOIS AND ANACHRONISTIC
IF YOU GOT YOUR JOB THROUGH THE "TIMES"
IT'S MORE CHIC TO MAKE OUT THROUGH A MYSTIC
WHO RECITES CABALISTICAL RHYMES
HAVE YOU WISHED THAT YOU WERE ANOTHER?
IS YOUR HOME-LIFE NOT FIT FOR A DOG?
SO I TURN STRAW TO GOLD FOR YOUR MOTHER, YOUR MOTHER-IN-LAW
IN TURN INTO A FROG!

Meanwhile, on the other side of town, the singing Sorcerer makes his way to **The Queen's Nose,** a piratical pub, where *Buccaneers* carouse and so forth. They are 'served' by *Rose Maybud* . . . a Wench.

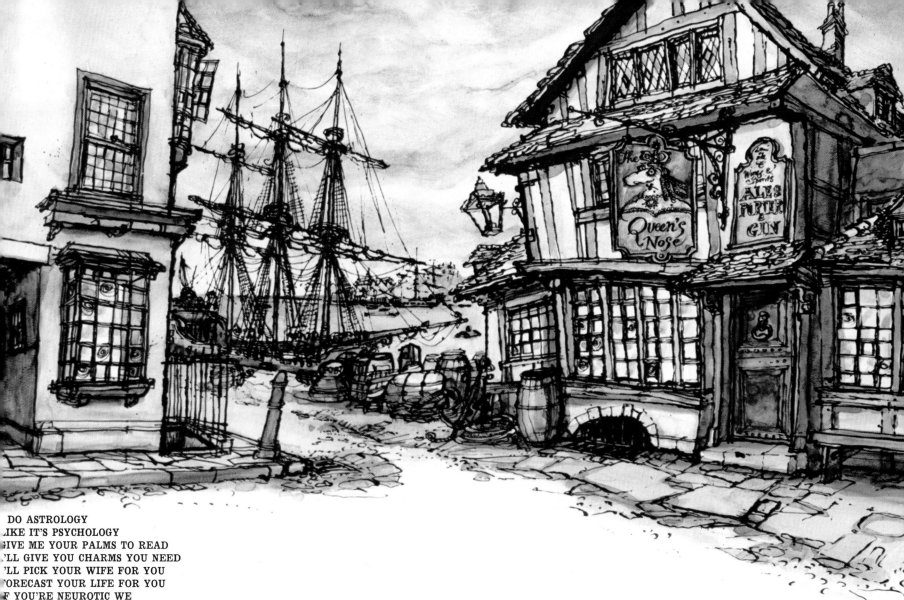

DO ASTROLOGY
LIKE IT'S PSYCHOLOGY
GIVE ME YOUR PALMS TO READ
'LL GIVE YOU CHARMS YOU NEED
'LL PICK YOUR WIFE FOR YOU
FORECAST YOUR LIFE FOR YOU
F YOU'RE NEUROTIC WE
CURE IT EXOTICALLY
TREAT IT HYPNOTICALLY

COUNSEL ON ETIQUETTE
YOU'LL EAT SPAGHETTI, YET!
GUARANTEE RACING TIPS
HOW WAYS OF KISSING LIPS
AND THAT'S NOT ALL, YOU SEE,
FOR IF YOU CALL ON ME
ALACAZAM! YOU GETS
EN-U-INE AMULETS
DI-RECT FROM EGYPT — AND FREE!

O – COME TO JOHN WELLINGTON WELLS
THE WHEELER AND DEALER IN SPELLS
F YOU SAY I'M A PHONEY
AND MAGIC'S BALONEY
BALONEY, SCHMALONEY, IT SELLS!

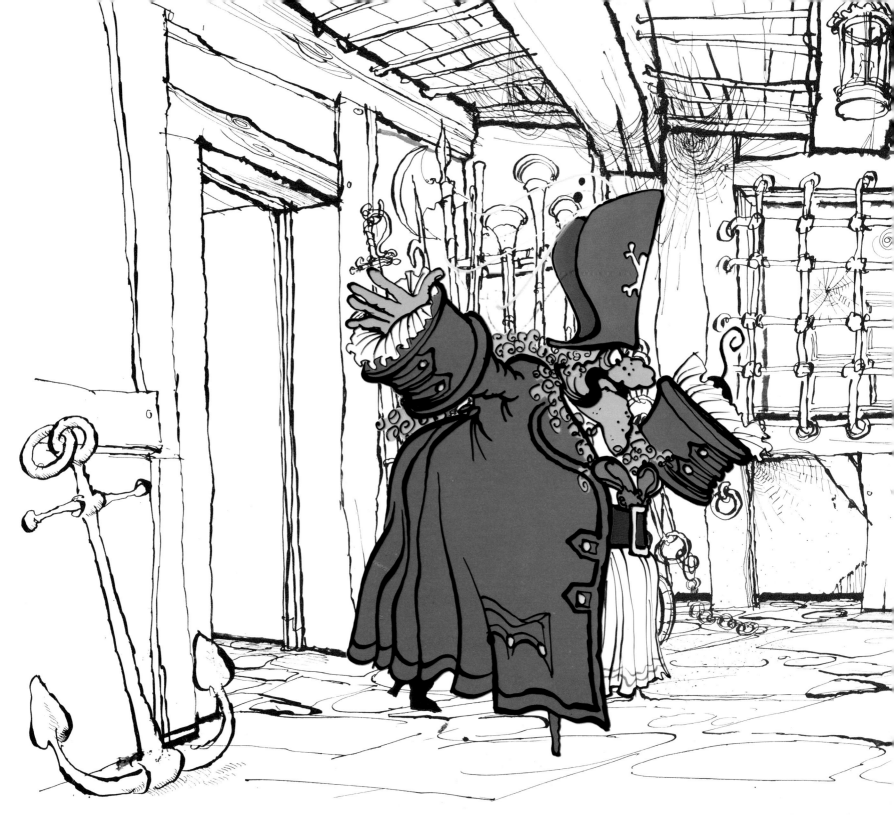

Inside the Q.N. **Sorcerer** and **Pirate King** retire to connive *in camera* regarding the Ultimate Secret.

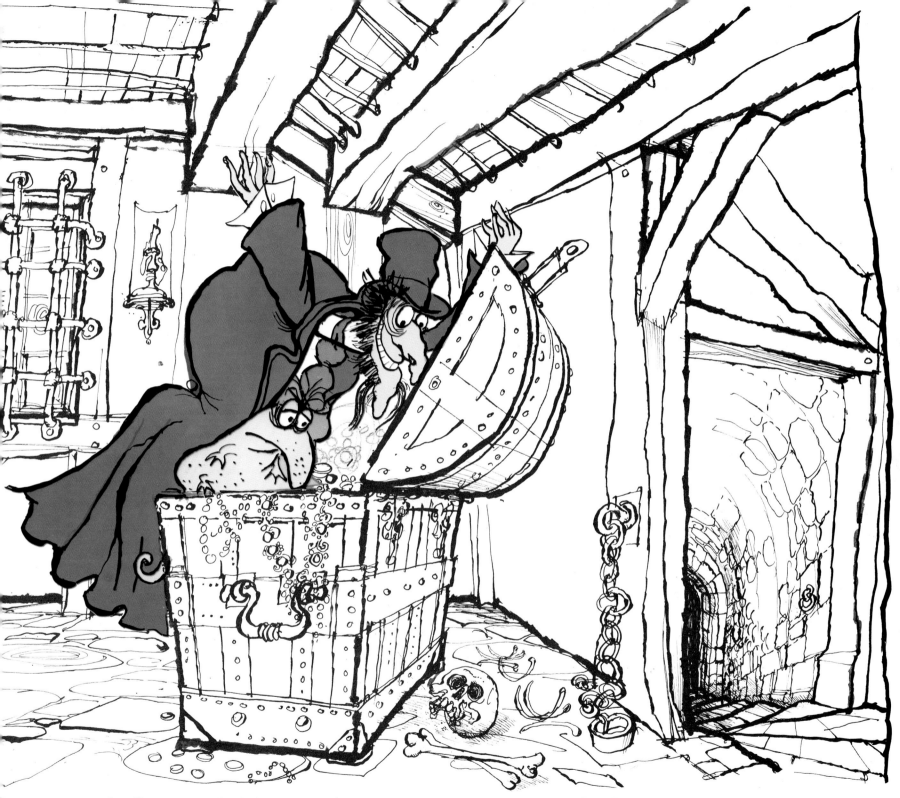

They agree the Sorcerer shall take the dwindling reserves of piratical bullion in exchange for the **U.S.** with which he promises to return, ho! ho!

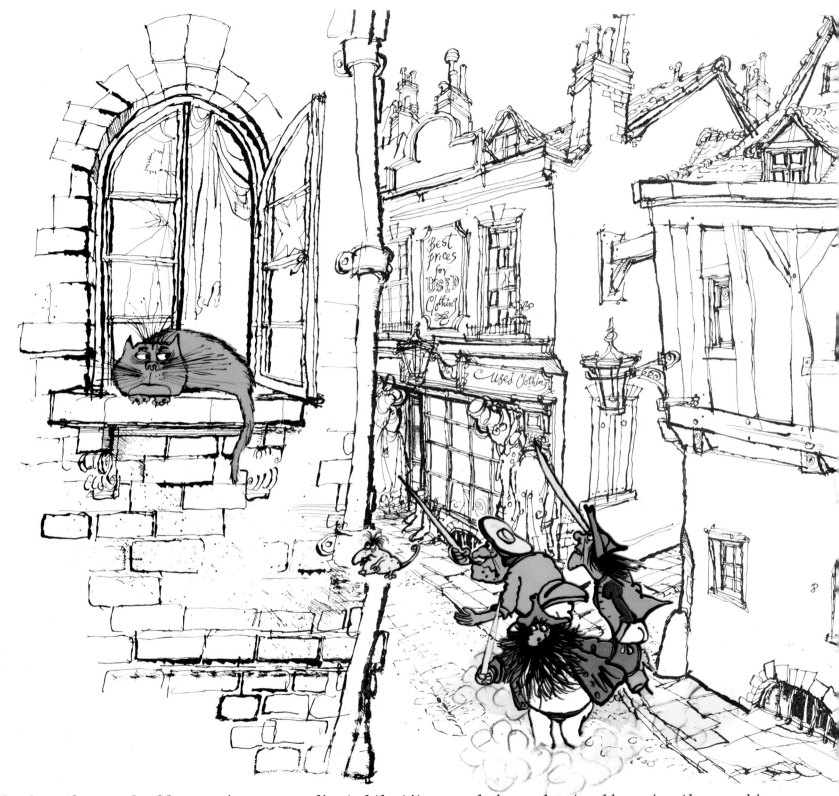

(*Here beginneth some double-crossing so complicated that it can only be understood by using the new binary mathematics*) Three pirates are deputed to follow the Sorcerer, who cunningly gives them the slip.

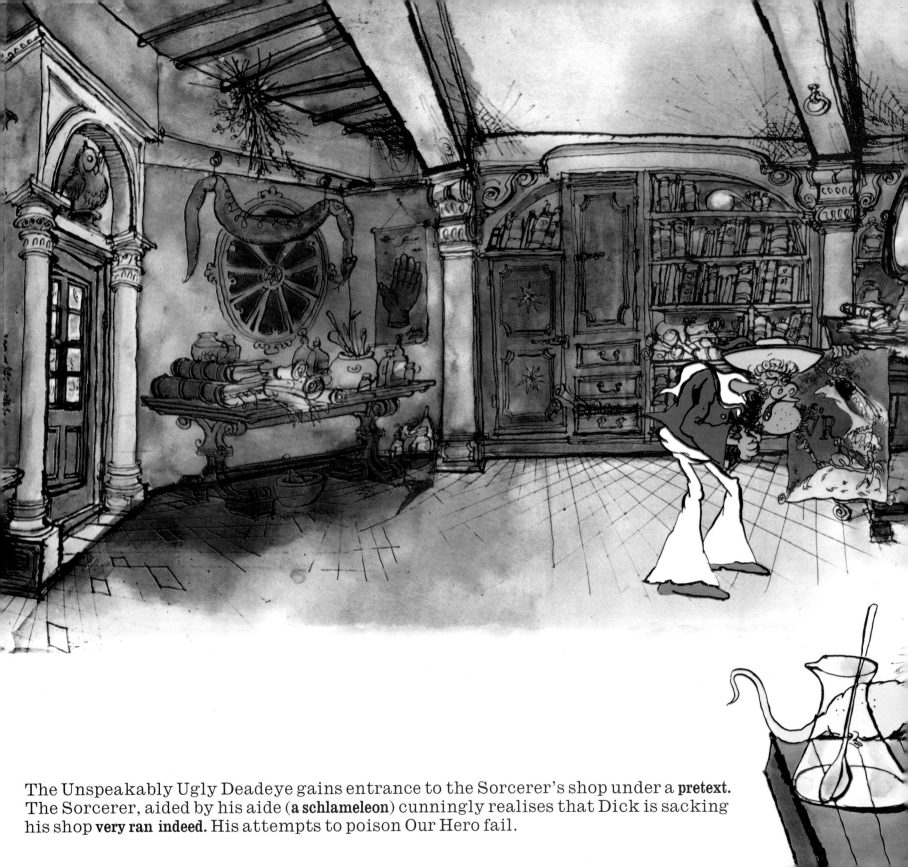

The Unspeakably Ugly Deadeye gains entrance to the Sorcerer's shop under a **pretext**. The Sorcerer, aided by his aide (**a schlameleon**) cunningly realises that Dick is sacking his shop **very ran indeed.** His attempts to poison Our Hero fail.

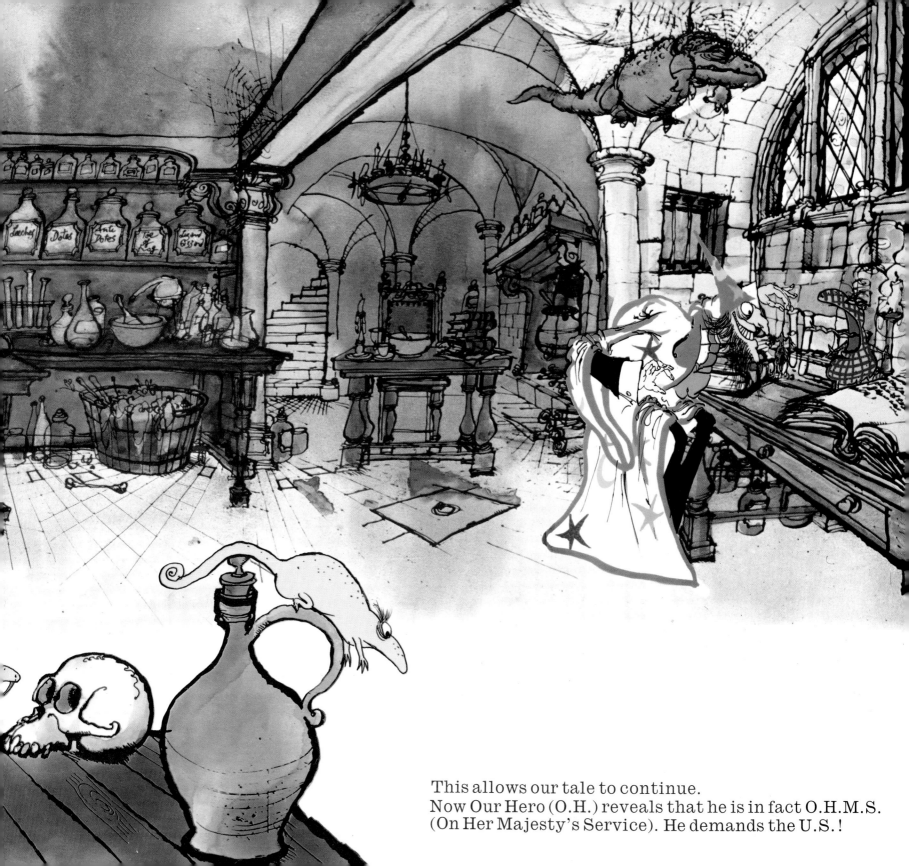

This allows our tale to continue.
Now Our Hero (O.H.) reveals that he is in fact O.H.M.S.
(On Her Majesty's Service). He demands the U.S.!

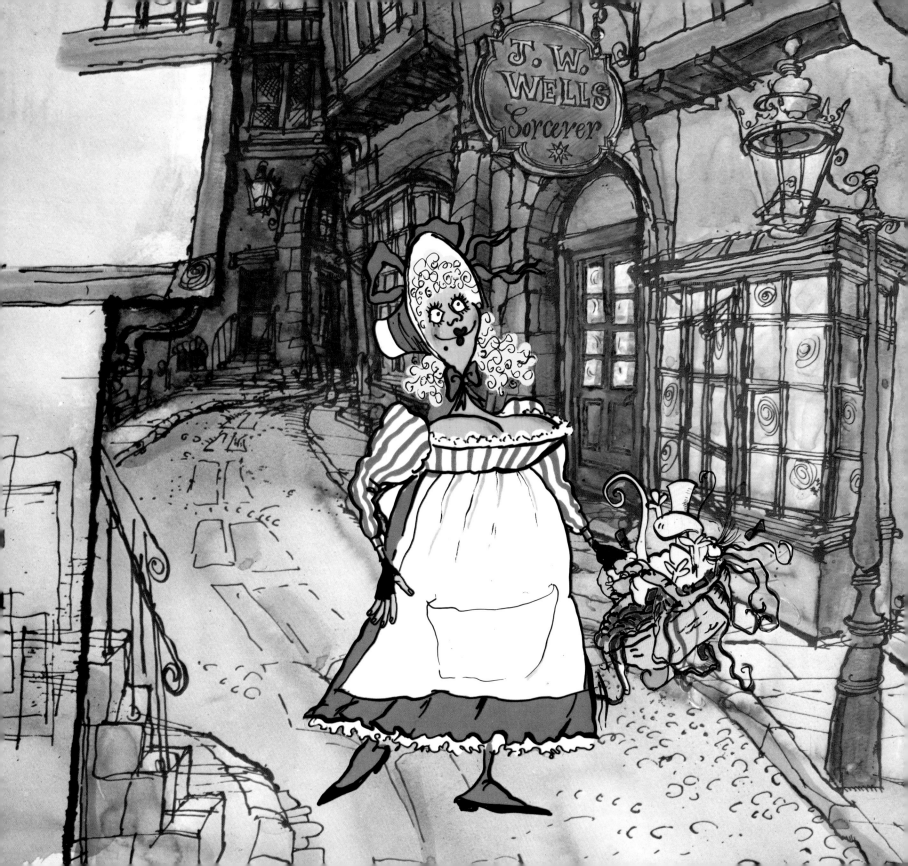

I'M CALLED LITTLE BUTTERCUP
DEAR LITTLE BUTTERCUP
WHICH I WOULD MUCH RATHER NOT
BUT MA CALLED ME BUTTERCUP
PA CALLED ME BUTTERCUP
PARENTS LIKE THAT SHOULD BE SHOT.

I HAVE A PROFESSION
I HAVE THE CONCESSION
TO PEDDLE MY WARES TO THE FLEET
BUT DON'T NUDGE AND WINK, FOR
IT'S NOT WHAT YOU THINK FOR
I ONLY SELL GOOD THINGS TO EAT

ALL FLAVOURS OF CANDY
RUM, WHISKY AND BRANDY
AND CAKES, PIES, JAMS, JULEPS AND ALES
LIKE MOTHER WOULD MAKE 'EM
LIKE GRANDMA WOULD BAKE 'EM
AND CUT PRICE FOR QUANTITY SALES.

SO BUY FROM YOUR BUTTERCUP
DEAR LITTLE BUTTERCUP
I HAVE WHAT FELLOWS ENJOY
YES BUY FROM YOUR BUTTERCUP
DEAR LITTLE BUTTERCUP
WHEN YOU HEAR BUTTERCUP'S AHOY
OH JOY!
BUY FROM YOUR BUTTERCUP, BOY!

The Sorcerer cunningly,
if unkindly, stuffs the U.S.
down the *Schlameleon's* mouth.
This worthy falls off the
window ledge into the basket
of BUTTERCUP, a passing basket.

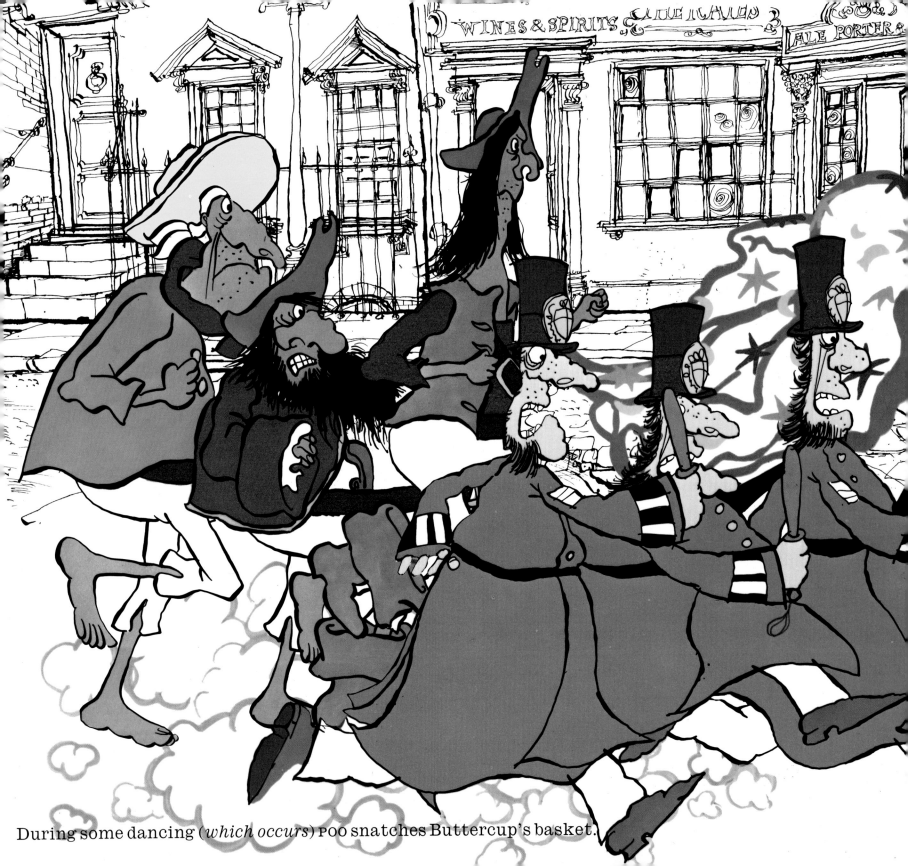

During some dancing (*which occurs*) POO snatches Buttercup's basket.

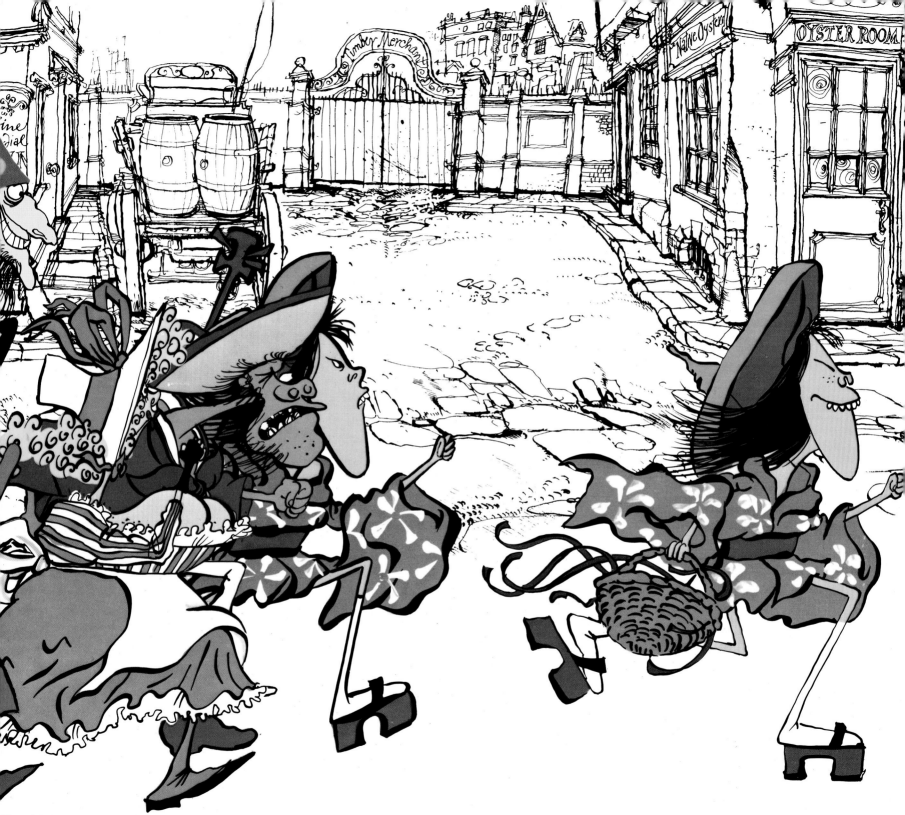

She indulges in some **Hue and Cry** pursued by everyone else, including some *Officers of the Law*.

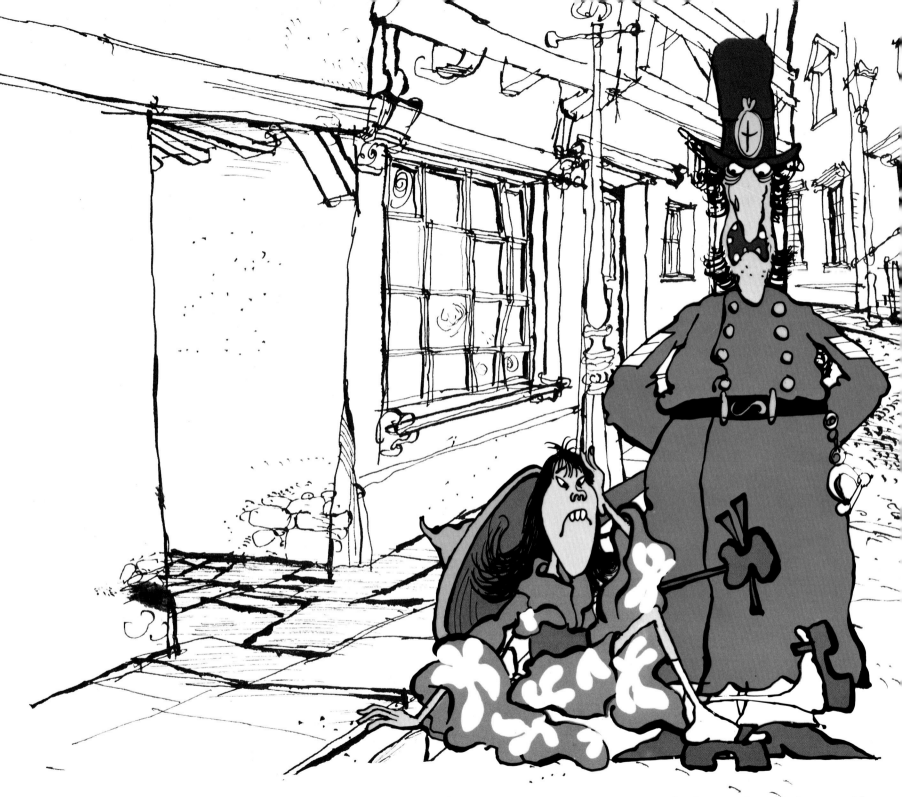

The chase takes the scenic route. The perfidious POO seeks refuge down a manhole, and nonplusses the pursuing NANKI with its cover. The chasers assume NANKI to be POO (**A mix up**).

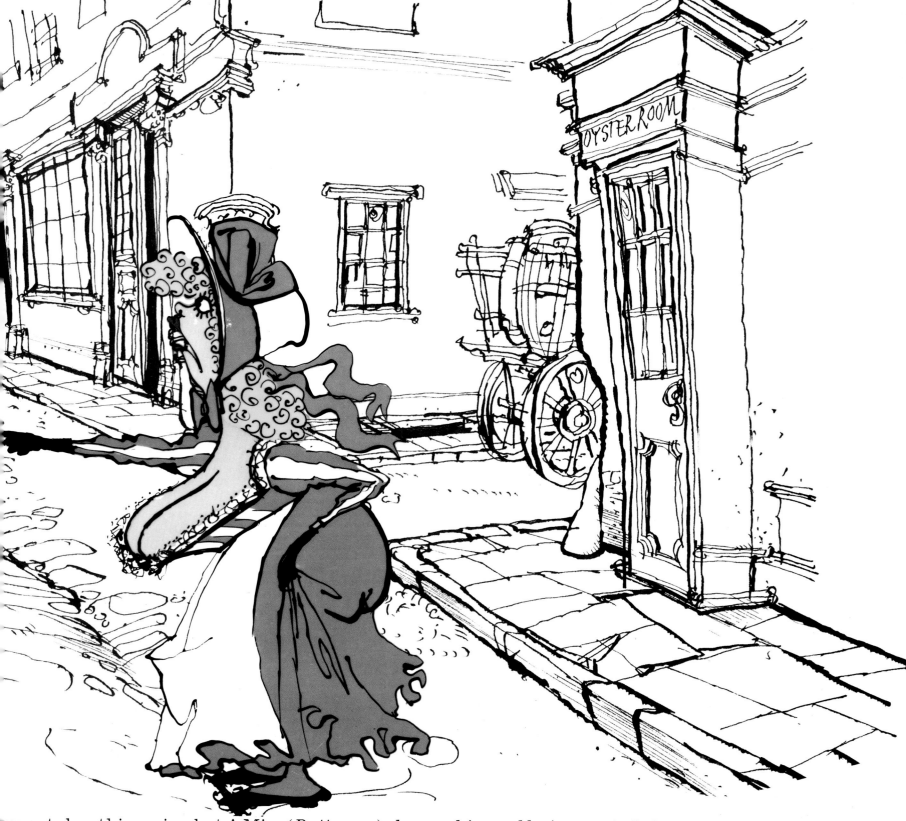

ʜᴀɴᴋɪ takes this amiss, but A Miss (*Buttercup*) charges him and he is arrested, despite being **U.S.-less.**

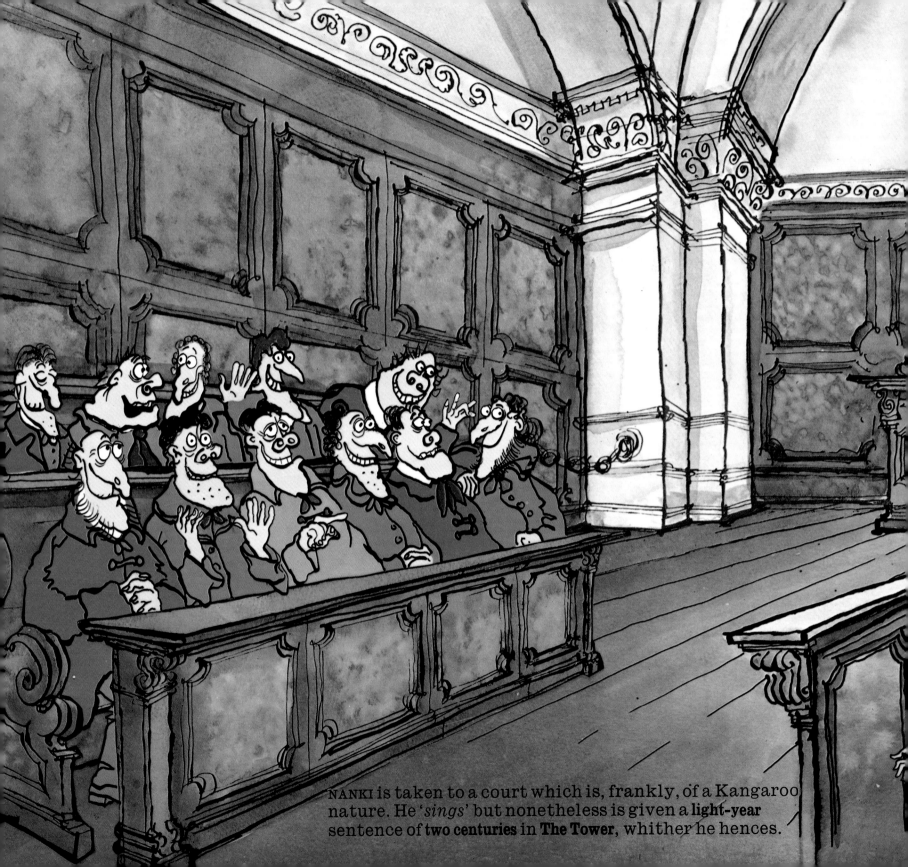

NANKI is taken to a court which is, frankly, of a Kangaroo nature. He '*sings*' but nonetheless is given a **light-year** sentence of **two centuries** in **The Tower**, whither he hences.

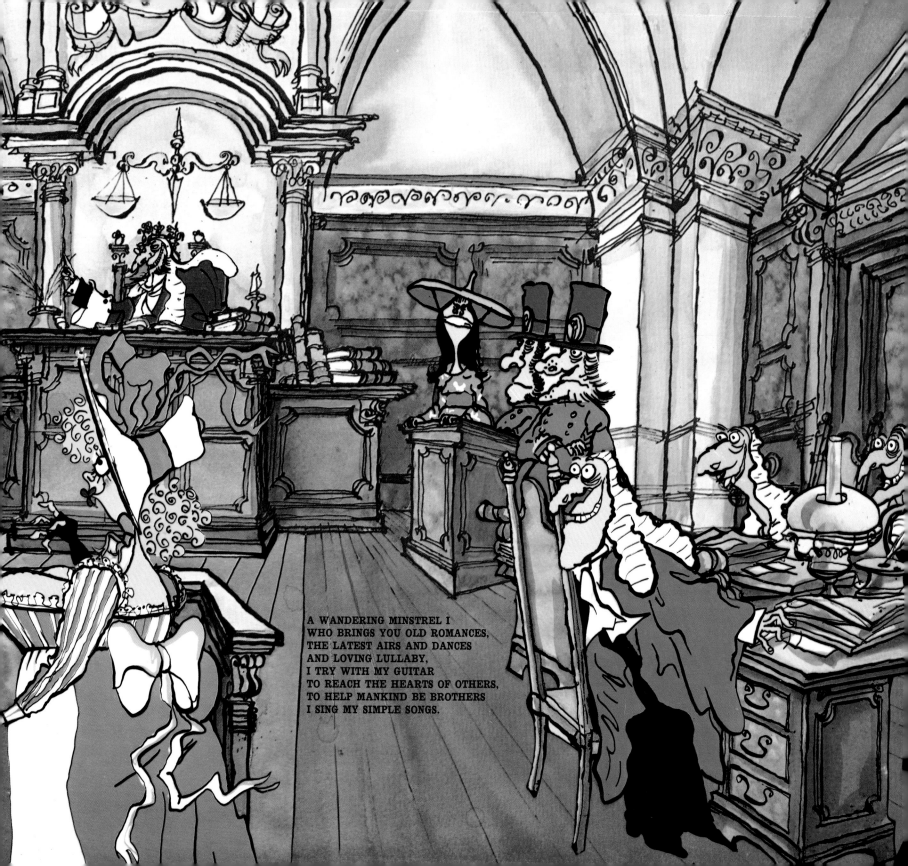

A WANDERING MINSTREL I
WHO BRINGS YOU OLD ROMANCES,
THE LATEST AIRS AND DANCES
AND LOVING LULLABY,
I TRY WITH MY GUITAR
TO REACH THE HEARTS OF OTHERS,
TO HELP MANKIND BE BROTHERS
I SING MY SIMPLE SONGS.

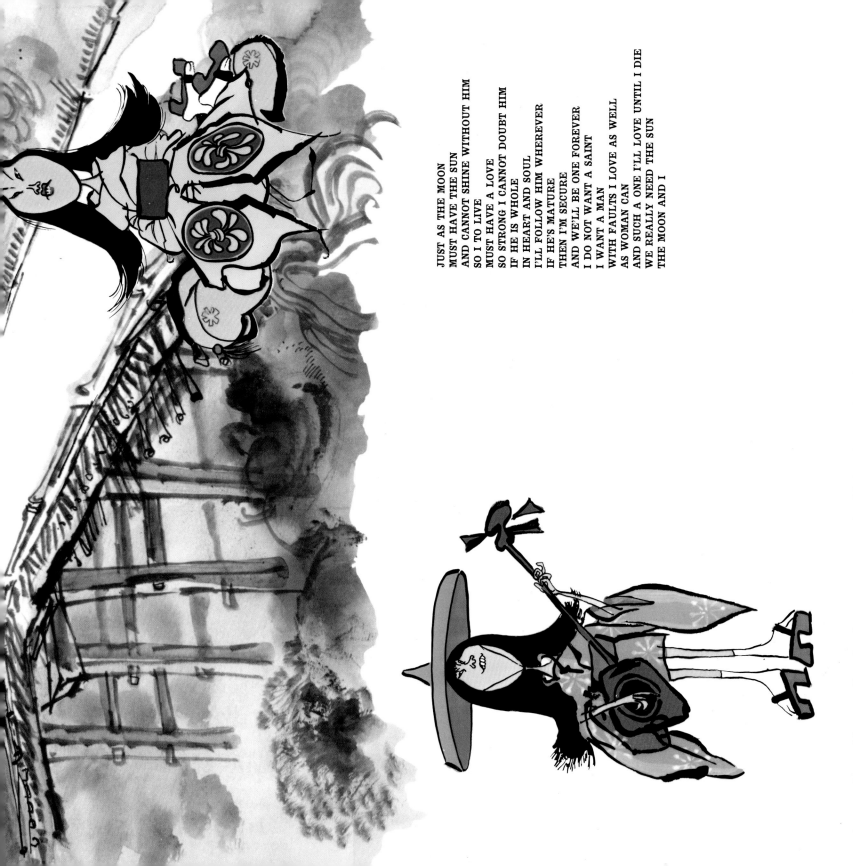

JUST AS THE MOON
MUST HAVE THE SUN
AND CANNOT SHINE WITHOUT HIM
SO I TO LIVE
MUST HAVE A LOVE
SO STRONG I CANNOT DOUBT HIM
IF HE IS WHOLE
IN HEART AND SOUL
I'LL FOLLOW HIM WHEREVER
IF HE'S MATURE
THEN I'M SECURE
AND WE'LL BE ONE FOREVER
I DO NOT WANT A SAINT
I WANT A MAN
WITH FAULTS I LOVE AS WELL
AS WOMAN CAN
AND SUCH A ONE I'LL LOVE UNTIL I DIE
WE REALLY NEED THE SUN
THE MOON AND I

NANKI's rather submissive response to this situation is to take out a Sami Sen (*guitar, made in Japan*) which he **Happens** to have with him, and fantasise about YUM YUM (*A Fantasy*)

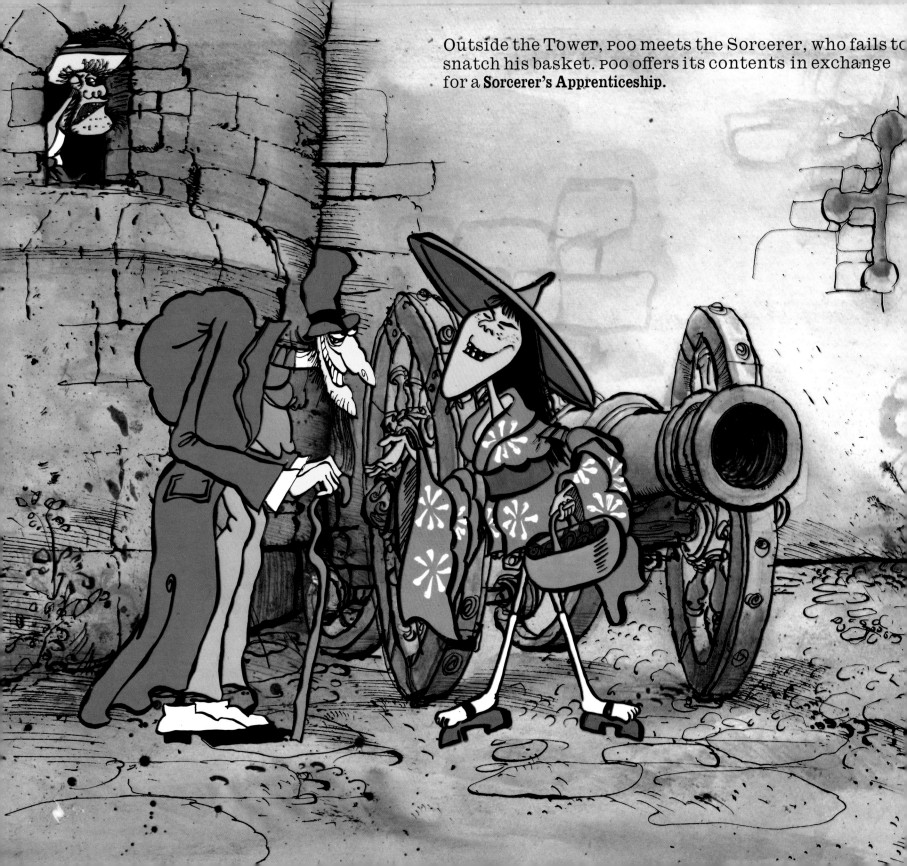

Outside the Tower, POO meets the Sorcerer, who fails to snatch his basket. POO offers its contents in exchange for a **Sorcerer's Apprenticeship.**

Dick and the Pirates (*who are on the trail*) (*and in the vicinity*) put several and several together and make several. A **Melee** ensues.

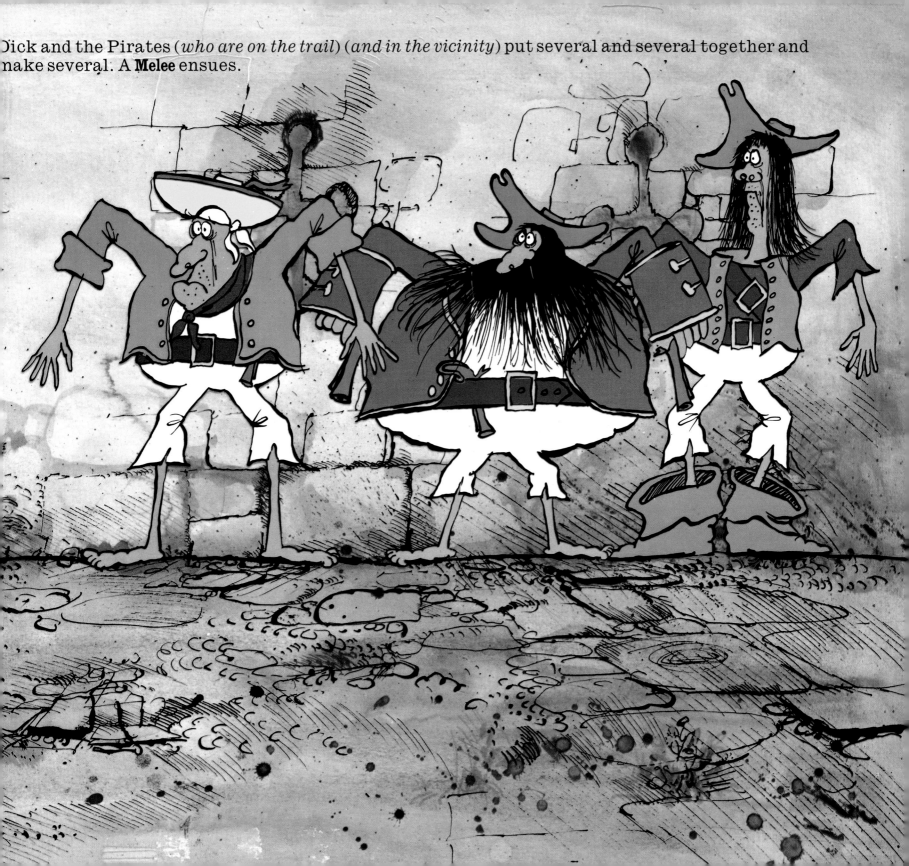

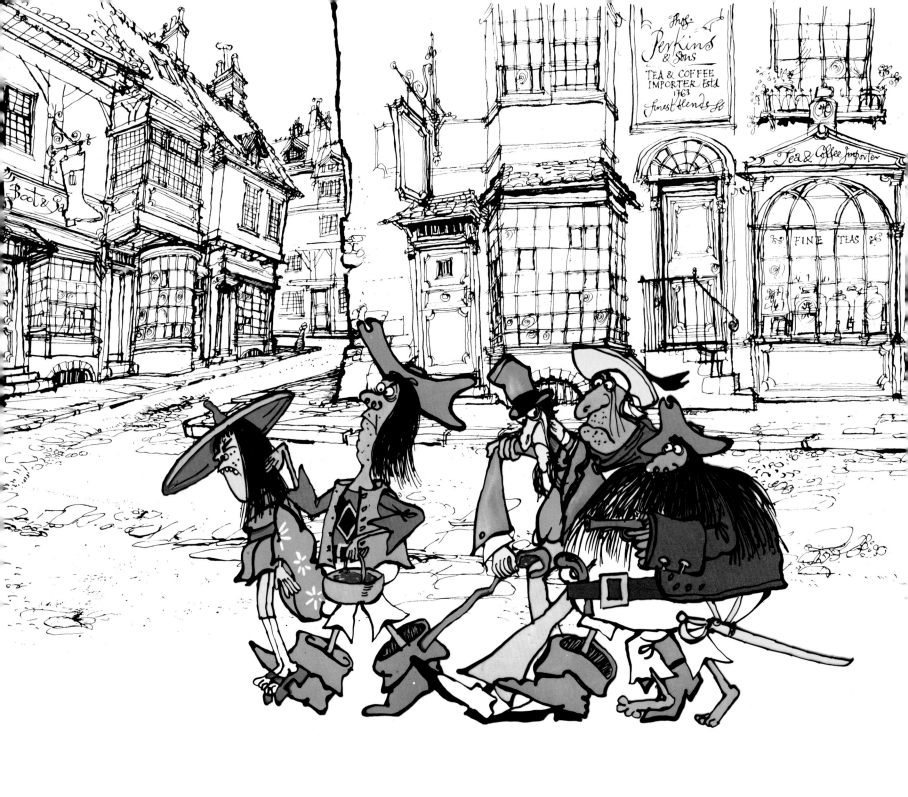

P.M. (*post melee*) Sorcerer, poo and Basket are marched off to **P.K.** (*Pirate King*).

Bursting into **The Queen's Nose** Dick bumps into Rose Maybud's bumpers. It is Love at first sight. They fantasize (P.T.O.)

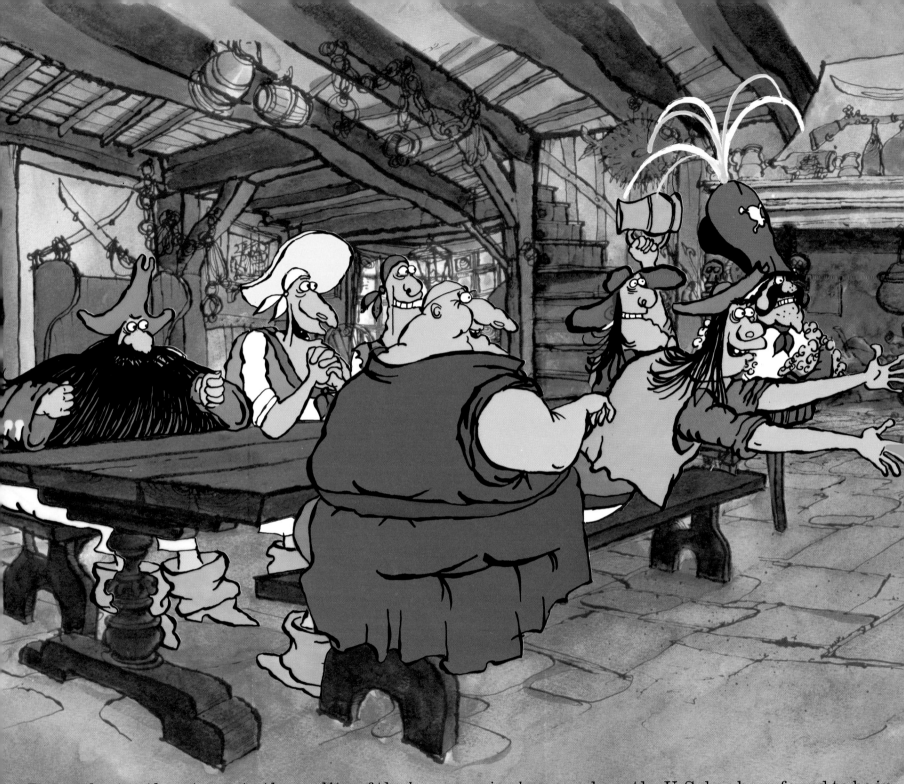

Rose reluctantly returns to the reality of the *buccaneering boozer*, where the U.S. has been found to be in C.O.D.E... **P.K.** and **J.W.W.** have agreed to decipher... aboard **P.K.'s Schooner**, which will sail immediately, if not sooner.

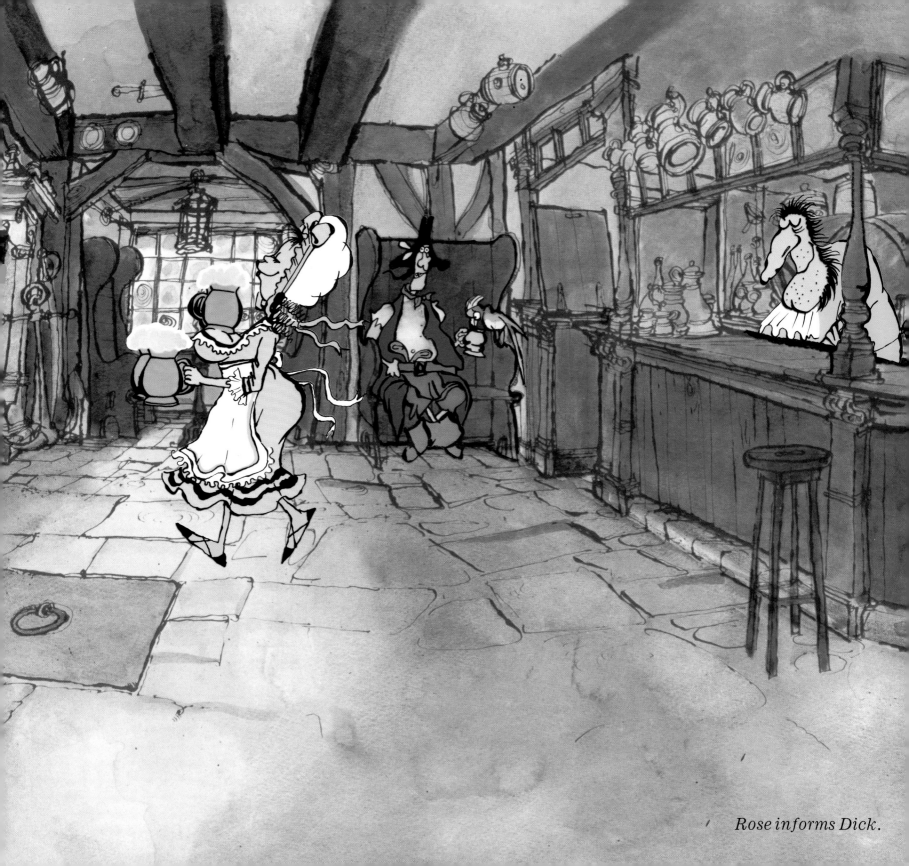

Rose informs Dick.

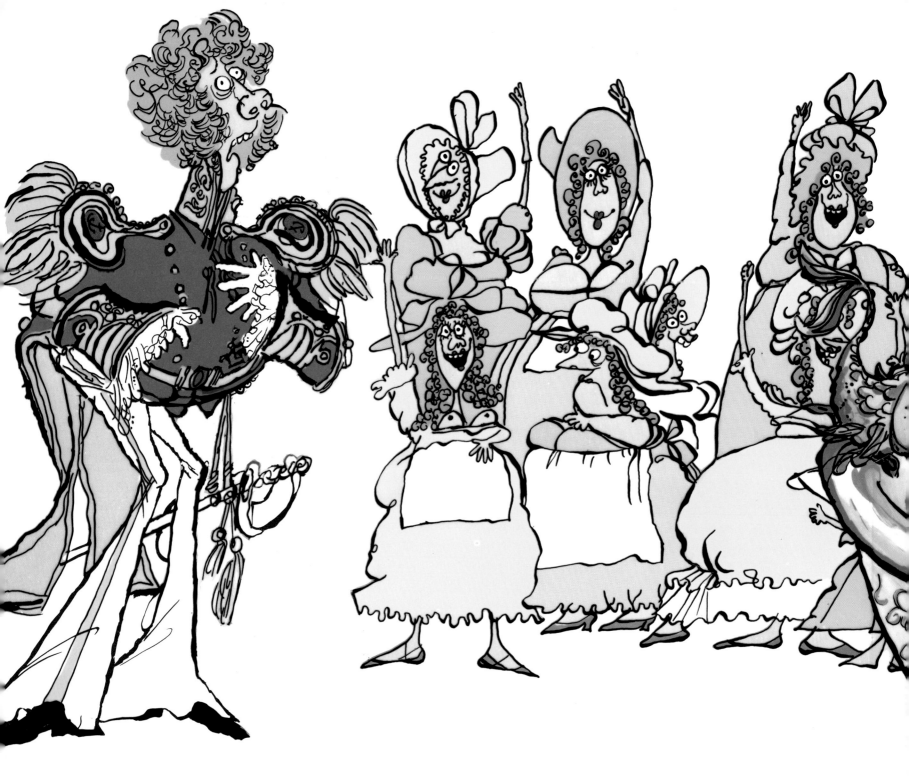

D.D. (O.H.) Streaks back to the **Hexagon**. Here he meets an Unadmirable Admiral (with his attendant relatives, who are relatively attendant) whom he rouses to action and together they rouse the Captain to action.

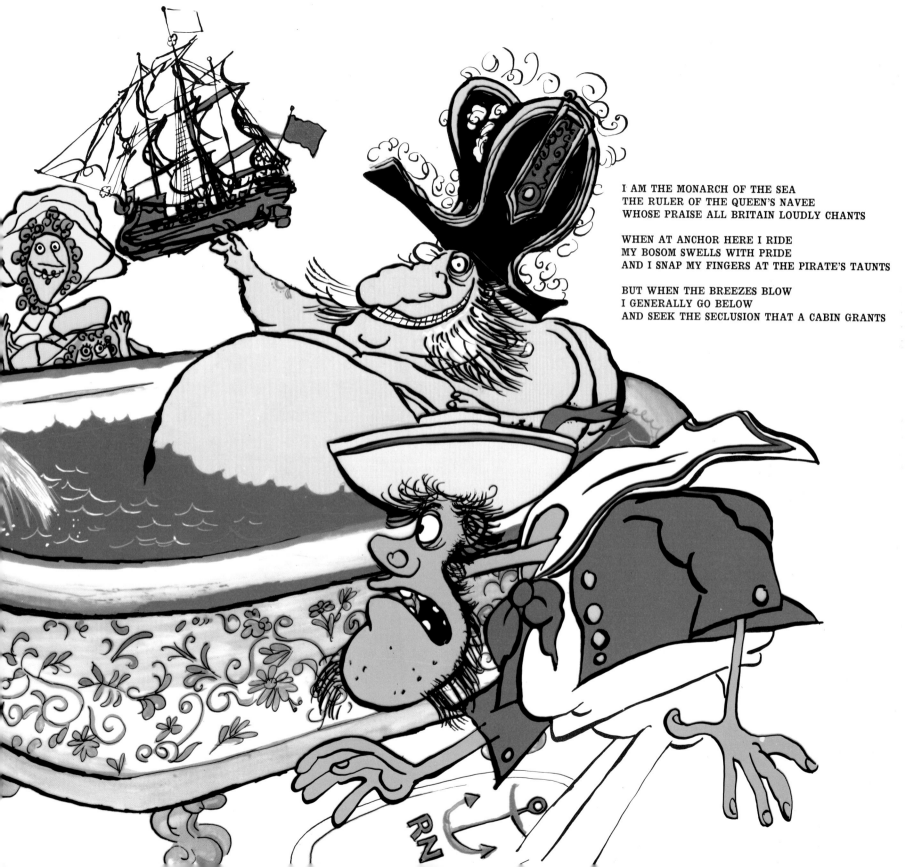

I AM THE MONARCH OF THE SEA
THE RULER OF THE QUEEN'S NAVEE
WHOSE PRAISE ALL BRITAIN LOUDLY CHANTS

WHEN AT ANCHOR HERE I RIDE
MY BOSOM SWELLS WITH PRIDE
AND I SNAP MY FINGERS AT THE PIRATE'S TAUNTS

BUT WHEN THE BREEZES BLOW
I GENERALLY GO BELOW
AND SEEK THE SECLUSION THAT A CABIN GRANTS

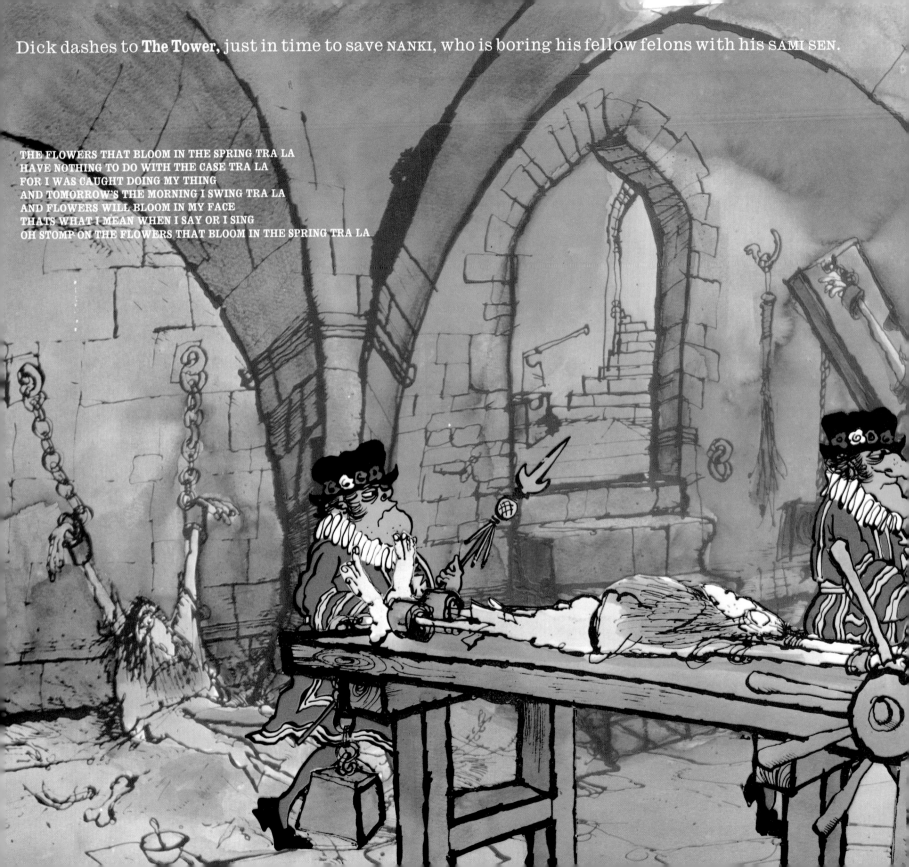

Dick dashes to **The Tower**, just in time to save NANKI, who is boring his fellow felons with his SAMI SEN.

THE FLOWERS THAT BLOOM IN THE SPRING TRA LA
HAVE NOTHING TO DO WITH THE CASE TRA LA
FOR I WAS CAUGHT DOING MY THING
AND TOMORROW'S THE MORNING I SWING TRA LA
AND FLOWERS WILL BLOOM IN MY FACE
THATS WHAT I MEAN WHEN I SAY OR I SING
OH STOMP ON THE FLOWERS THAT BLOOM IN THE SPRING TRA LA

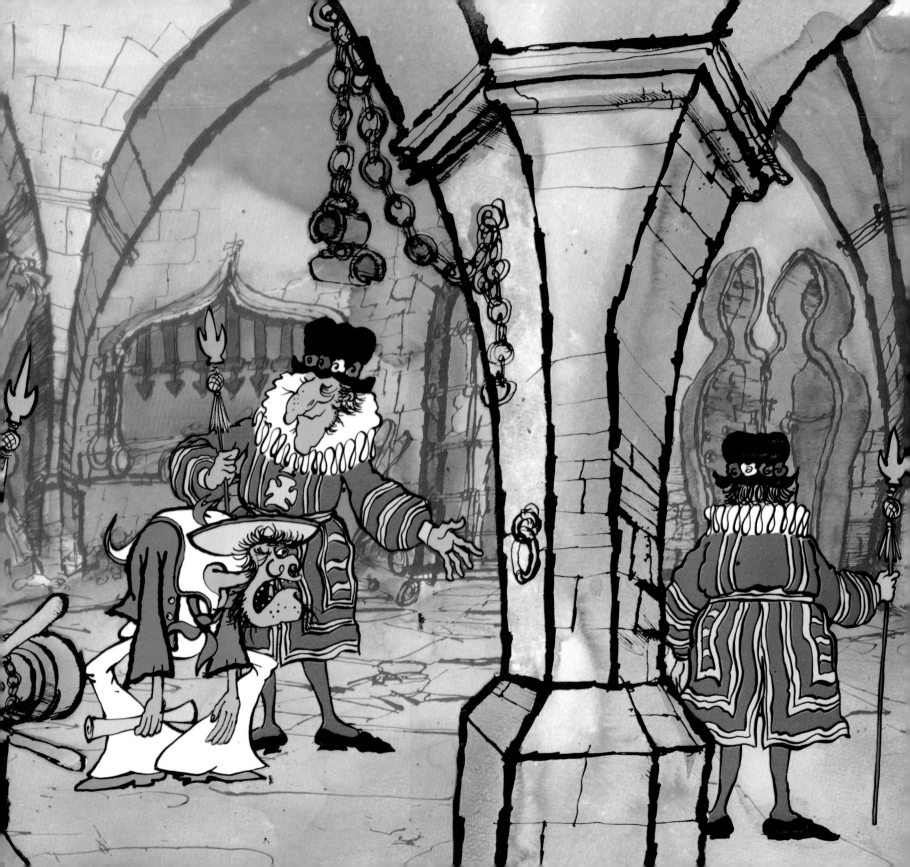

The Pirates board their ship. ROSE 'waylays' one, assumes his garb as a *Disguise*, and bawds the ship.

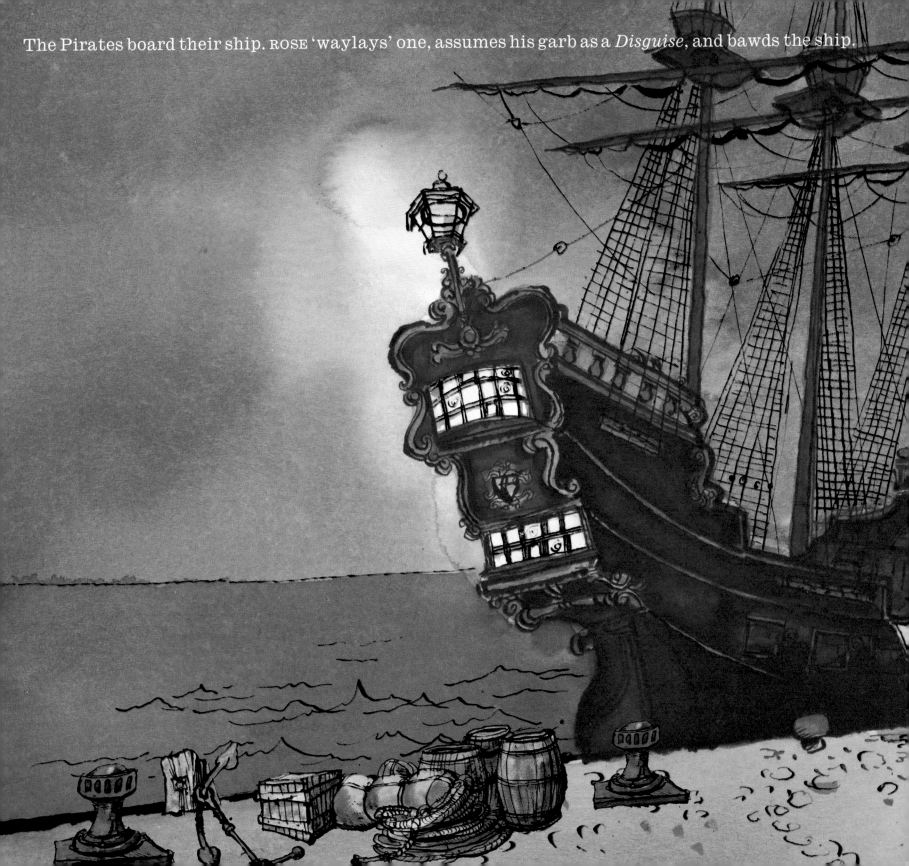

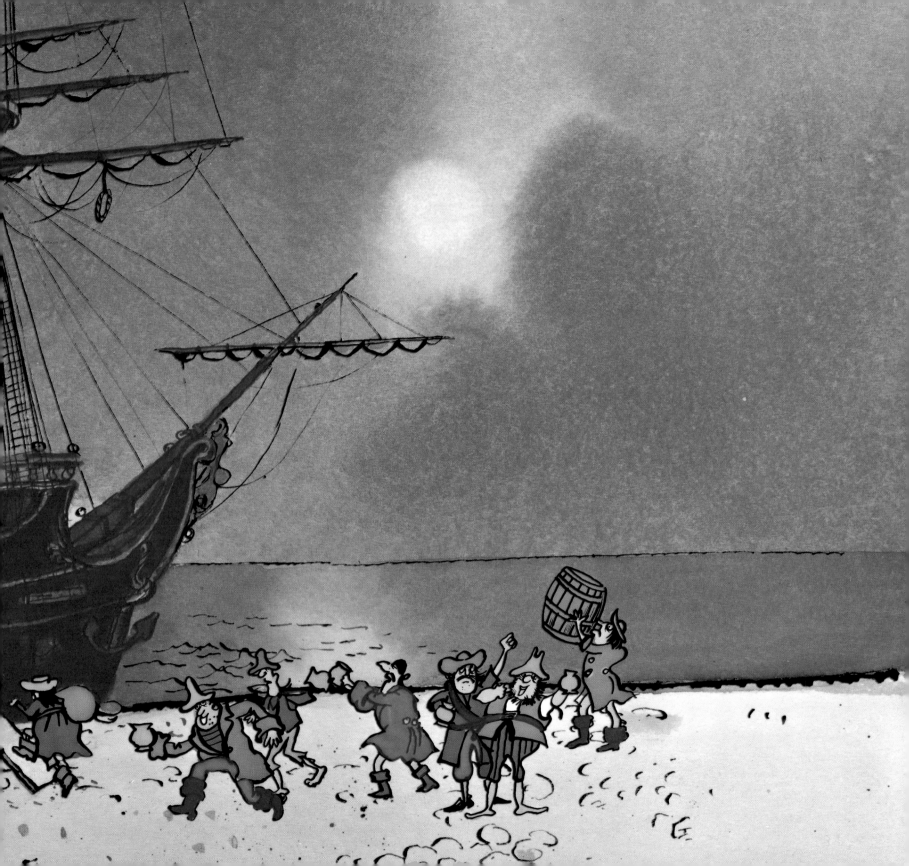

Back at the Harbour (*figure of speech; we haven't been there yet*)
Dick and his ex-inmates board **Pinafore**. They are seen off by various
DIGNITARIES, who, frankly, aren't about to risk *their* skins.
Pinafore remains in Harbour. She is still anchored.
Dick cleverly *Hoists* the anchor. (**He did it!!**)

GO YE HEROES, GO TO GLORY
THOUGH YOU DIE IN COMBAT GORY
YOU SHALL LIVE IN SONG AND STORY
GO TO IMMORTALITY!
GO TO DEATH, AND GO TO SLAUGHTER

DIE AND EVERY BRITISH DAUGHTER
WITH HER TEARS YOUR GRAVE SHALL WATER
GO YE HEROES GO AND DIE

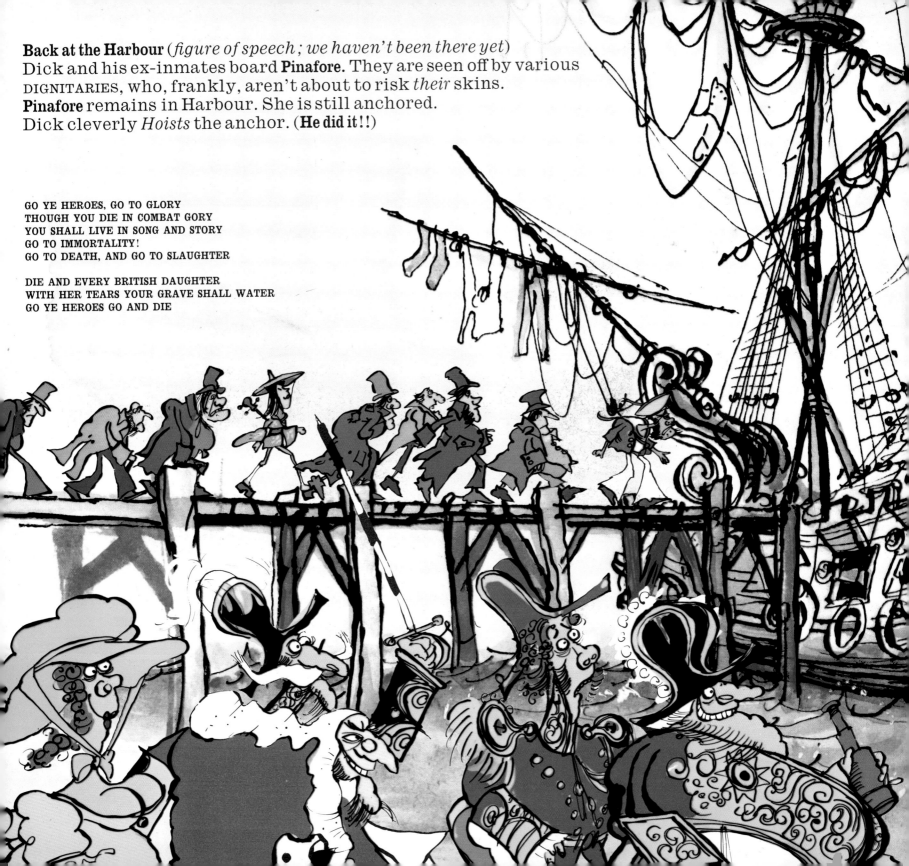

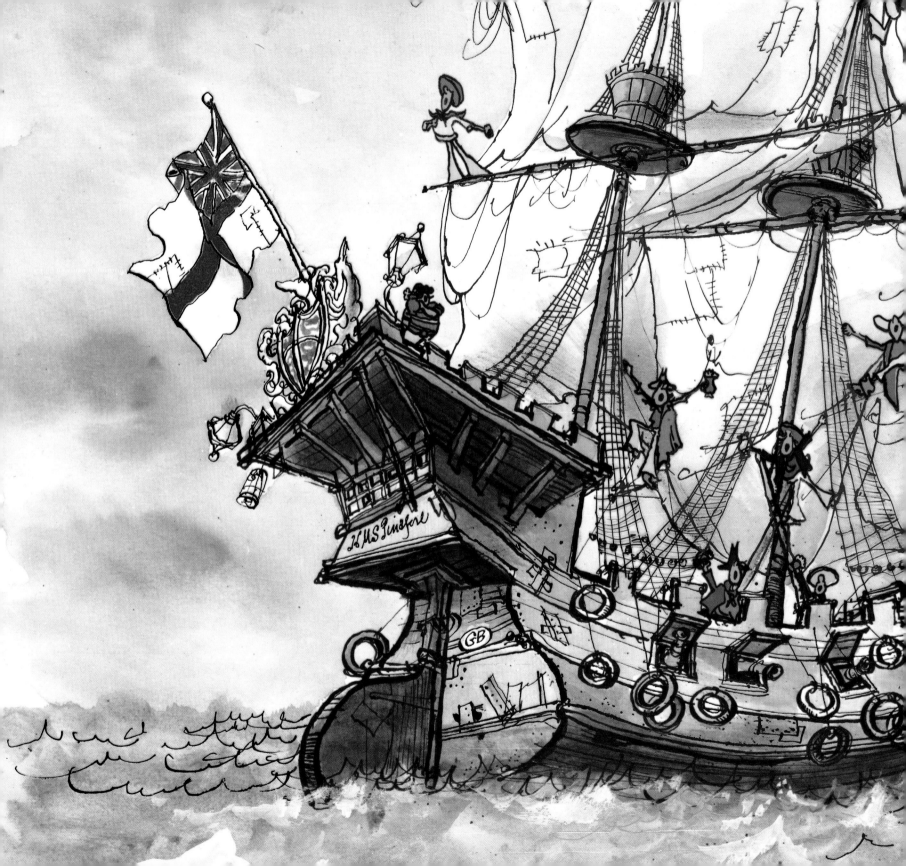

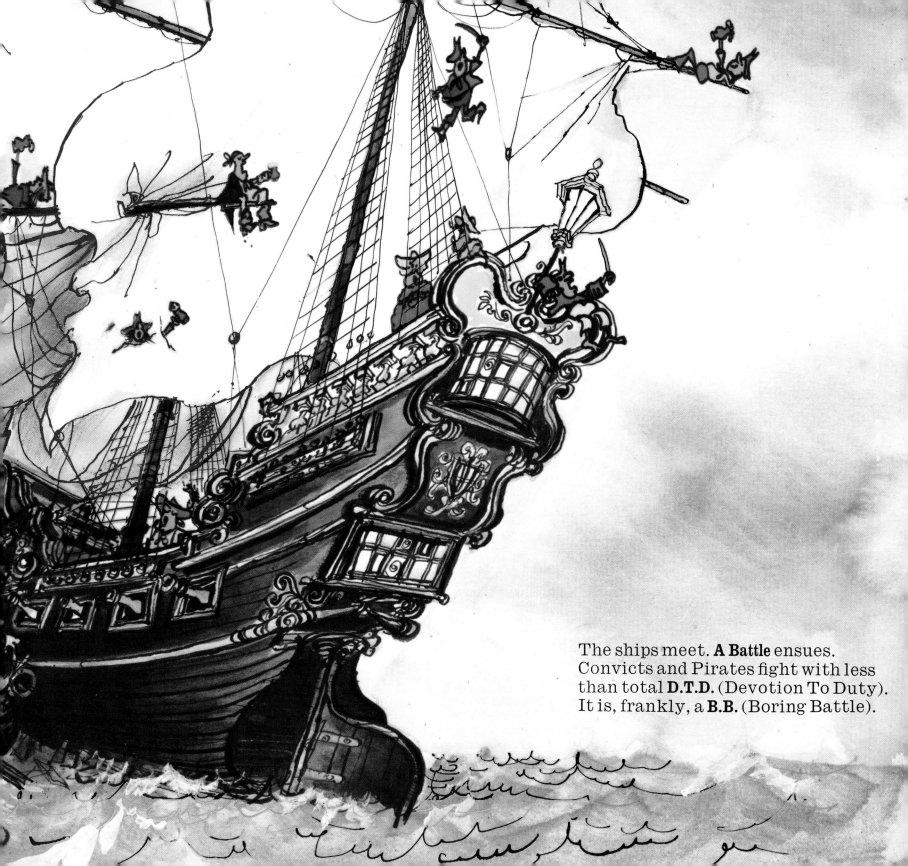

The ships meet. **A Battle** ensues.
Convicts and Pirates fight with less
than total **D.T.D.** (Devotion To Duty).
It is, frankly, a **B.B.** (Boring Battle).

Buttercup thinks back to her past...

A MANY YEARS AGO
I USED TO BE A NURSEMAID
I LOVED THE WORK BUT OH!
THERE NEVER WAS A WORSE MAID

SHE WAS A MOST PERVERSE MAID
THOUGH SHE BECAME A NURSEMAID
THERE NEVER WAS A WORSE MAID
A MANY YEARS AGO

TWO TOTS WERE IN MY CARE
AND OH HOW STRANGE WAS MY LO...
ONE WAS A PIRATE'S HEIR
AND ONE A RIVER PILOT'S

A PIRATE AND PILOT
THESE NURSEMAIDS ARE A SLY LOT...
DO WE DETECT A VILE PLOT
A MANY YEARS AGO.

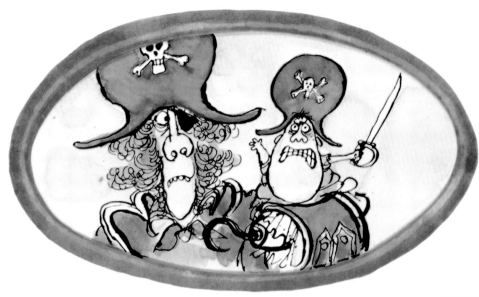

OH BITTER IS MY CUP
HOWEVER COULD I DO IT
MIXED THOSE CHILDREN UP
AND NOT A CREATURE KNEW IT!

HOWEVER COULD YOU DO IT
TODAY NO DOUBT YOU RUE IT
ALTHOUGH NO CREATURE KNEW IT
MANY YEARS AGO.

YES, THAT WAS WORSE THAN BAD
BUT NOW FOR NEWS THAT'S WORSER
YOU WERE THE PIRATE'S LAD
AND YOU THE VICE VERSA!

YES THIS GETS WORSE AND WORSER
THEY VERY WELL MAY CURSE HER
THEY BOTH WERE VICE VERSA
MANY YEARS AGO!

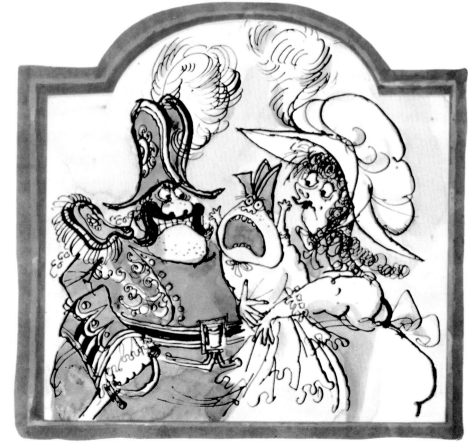

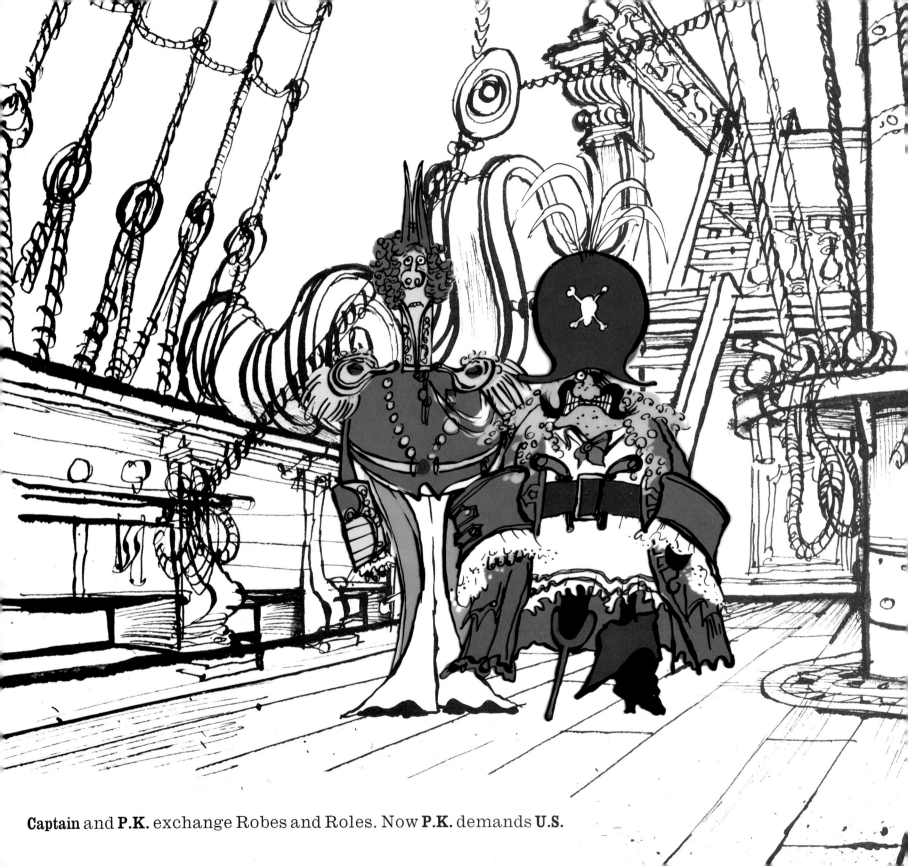

Captain and **P.K.** exchange Robes and Roles. Now **P.K.** demands **U.S.**

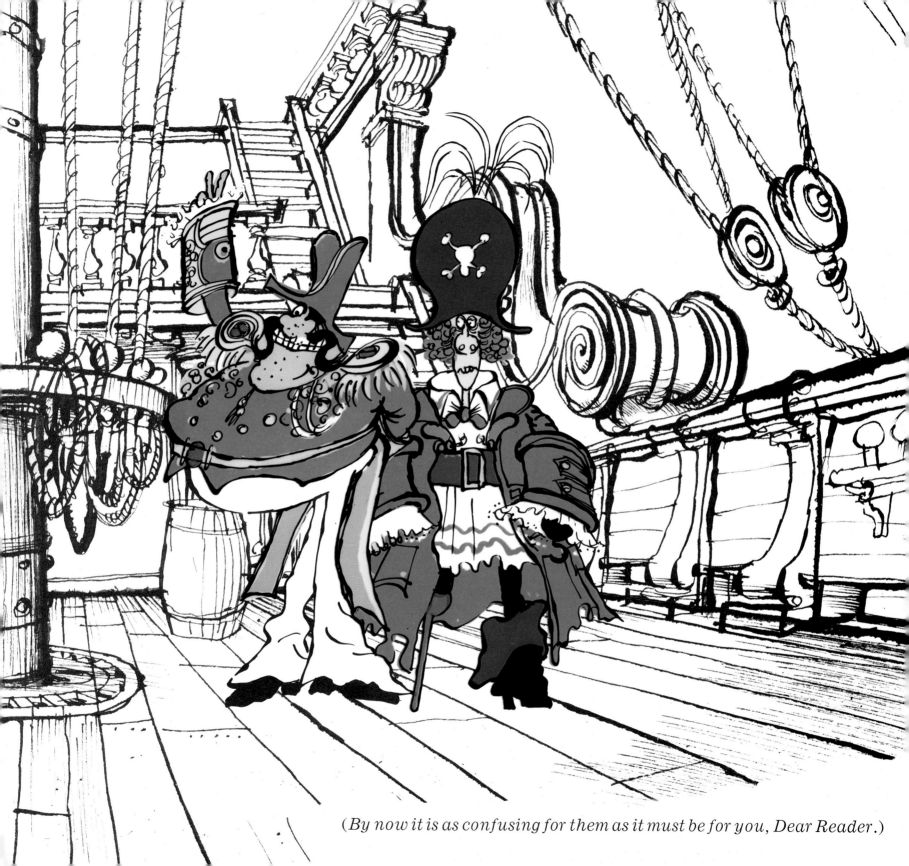

(By now it is as confusing for them as it must be for you, Dear Reader.)

200 is spied escaping to a **Tropical Island!**

Everyone follows his footsteps.

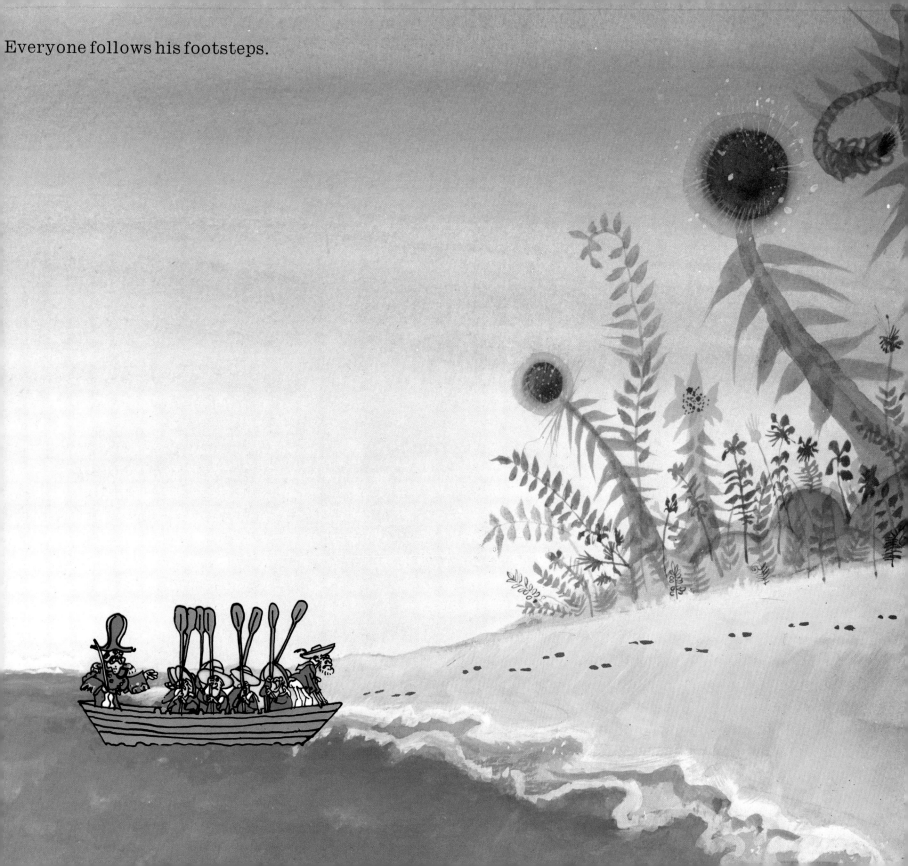

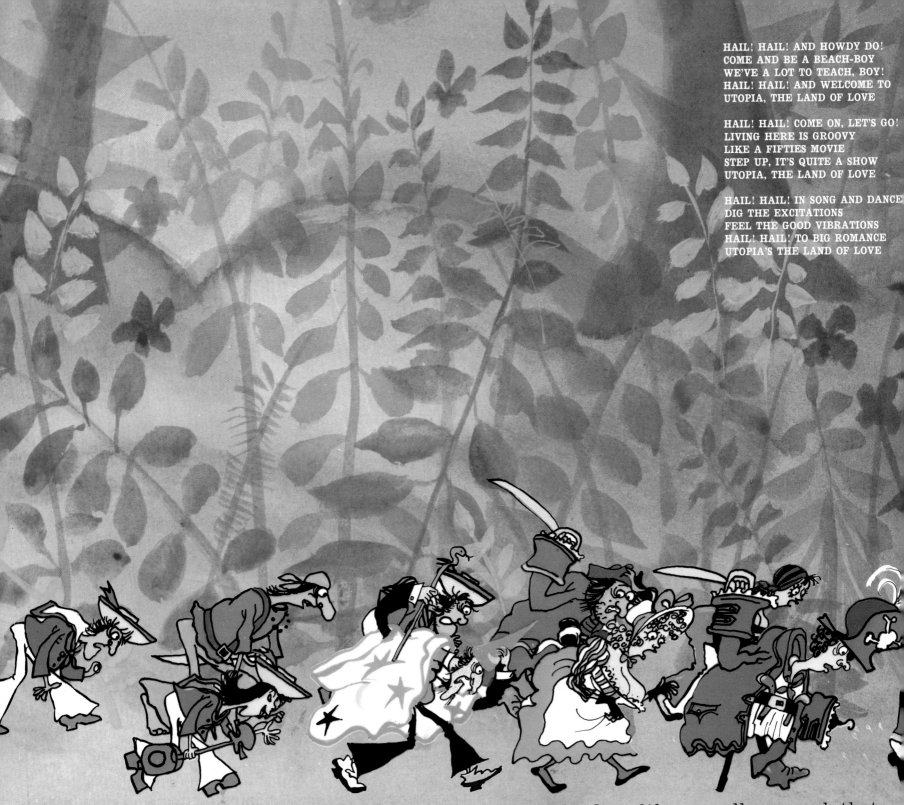

HAIL! HAIL! AND HOWDY DO!
COME AND BE A BEACH-BOY
WE'VE A LOT TO TEACH, BOY!
HAIL! HAIL! AND WELCOME TO
UTOPIA, THE LAND OF LOVE

HAIL! HAIL! COME ON, LET'S GO!
LIVING HERE IS GROOVY
LIKE A FIFTIES MOVIE
STEP UP, IT'S QUITE A SHOW
UTOPIA, THE LAND OF LOVE

HAIL! HAIL! IN SONG AND DANCE
DIG THE EXCITATIONS
FEEL THE GOOD VIBRATIONS
HAIL! HAIL! TO BIG ROMANCE
UTOPIA'S THE LAND OF LOVE

They are met by some toweringly *Lovely Ladies*, whose clad is light. One of these revellers reveals that this is **Utopia.** (*She has precious little else left to reveal.*)

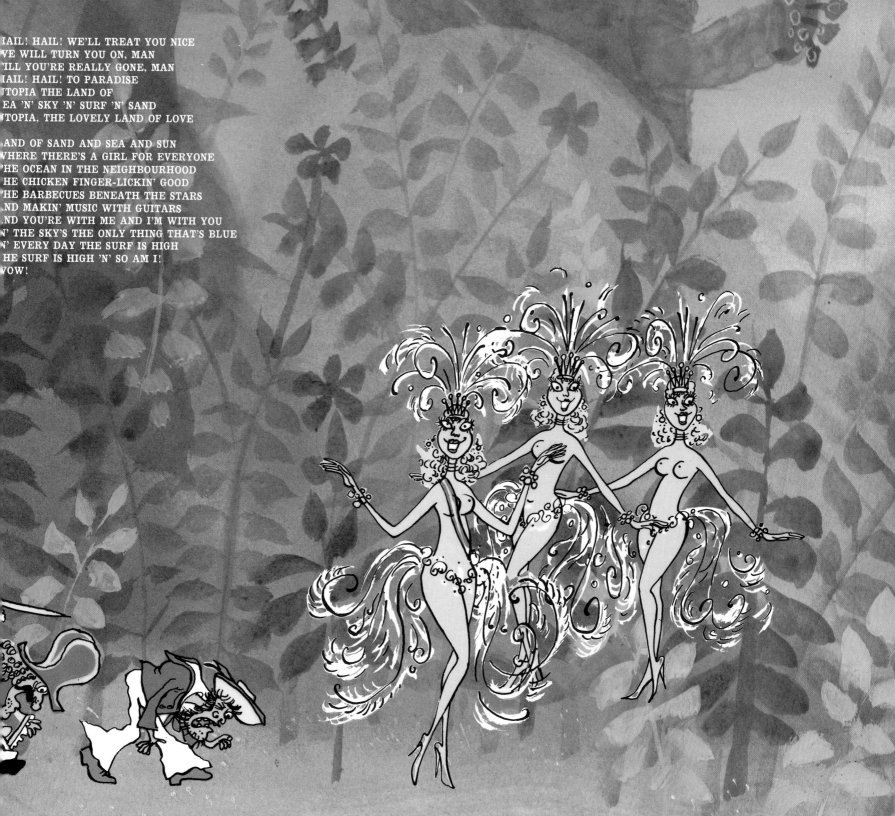

HAIL! HAIL! WE'LL TREAT YOU NICE
WE WILL TURN YOU ON, MAN
'ILL YOU'RE REALLY GONE, MAN
HAIL! HAIL! TO PARADISE
UTOPIA THE LAND OF
EA 'N' SKY 'N' SURF 'N' SAND
UTOPIA, THE LOVELY LAND OF LOVE

AND OF SAND AND SEA AND SUN
WHERE THERE'S A GIRL FOR EVERYONE
HE OCEAN IN THE NEIGHBOURHOOD
HE CHICKEN FINGER-LICKIN' GOOD
HE BARBECUES BENEATH THE STARS
ND MAKIN' MUSIC WITH GUITARS
ND YOU'RE WITH ME AND I'M WITH YOU
N' THE SKY'S THE ONLY THING THAT'S BLUE
N' EVERY DAY THE SURF IS HIGH
HE SURF IS HIGH 'N' SO AM I!
VOW!

She herself is revealed to be **Princess Zara,** who is acting locum to *The Queen* (not *our* Queen, THEIR Queen).

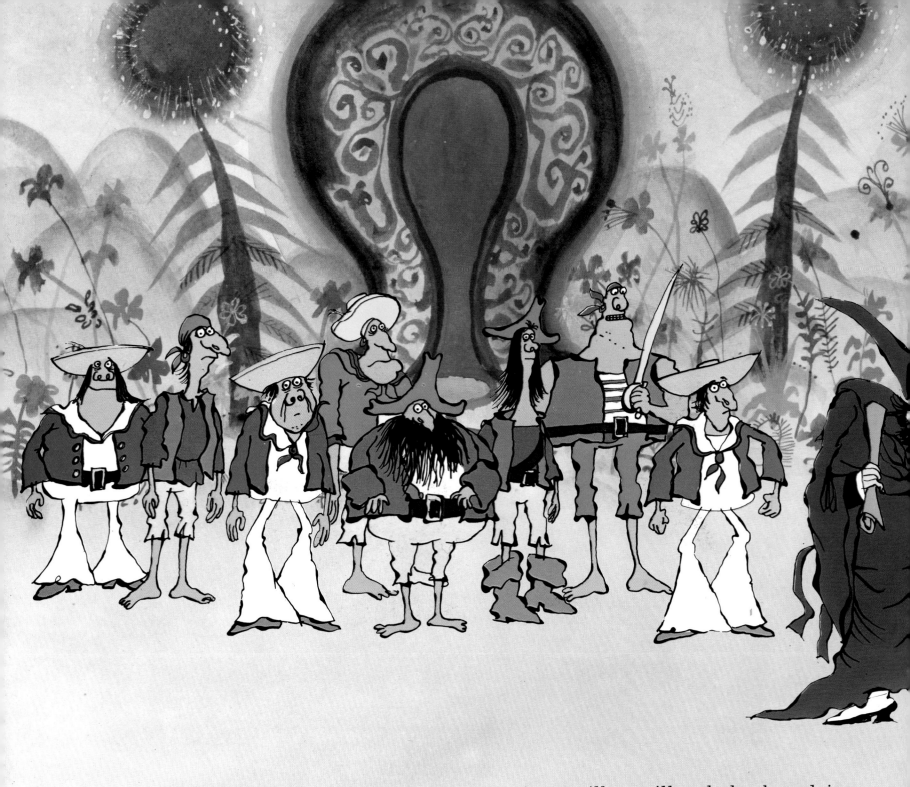

On enquiry, POO is revealed to be in the Stocks on account of some village-pillage he has been doing. **Execution** is proposed. There is NO executioner. The Sorcerer offers himself and abstracts the **U.S.** from POO'S PERSON!

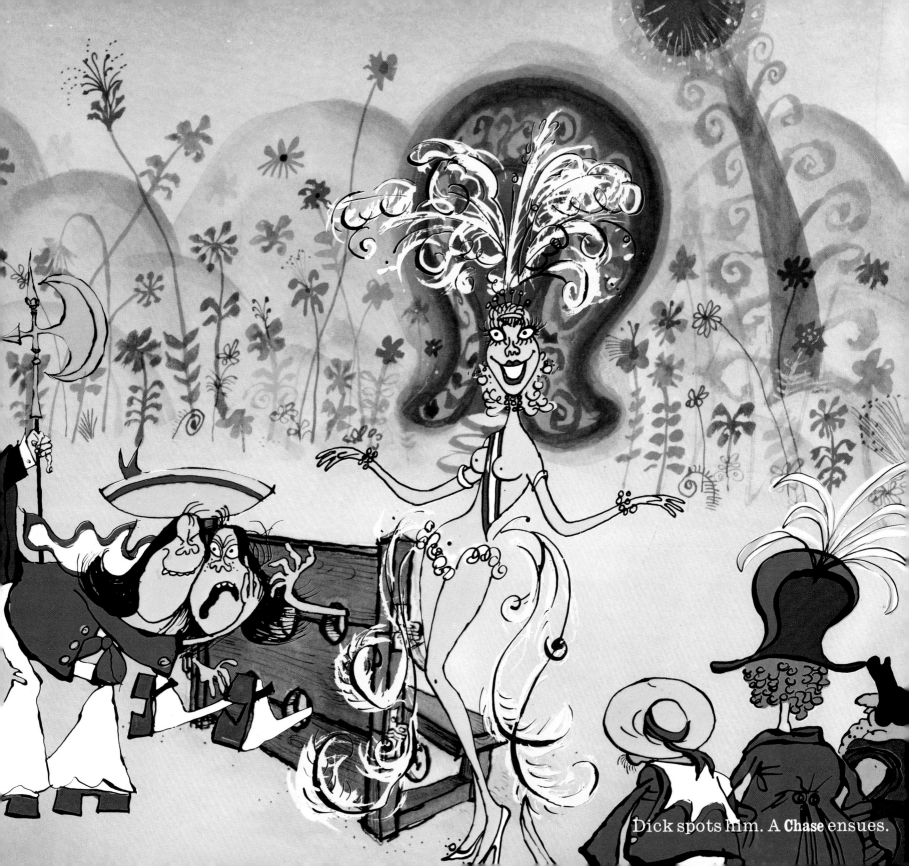

Dick spots him. A **Chase** ensues.

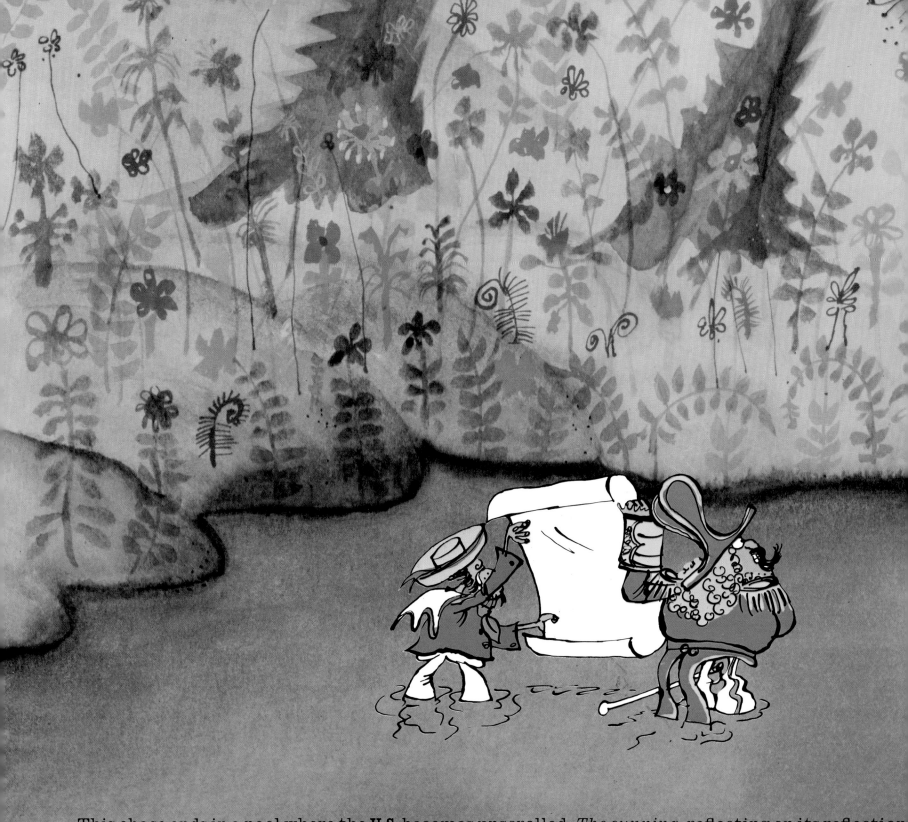

This chase ends in a pool where the **U.S.** becomes unscrolled. *The cunning*, reflecting on its reflection

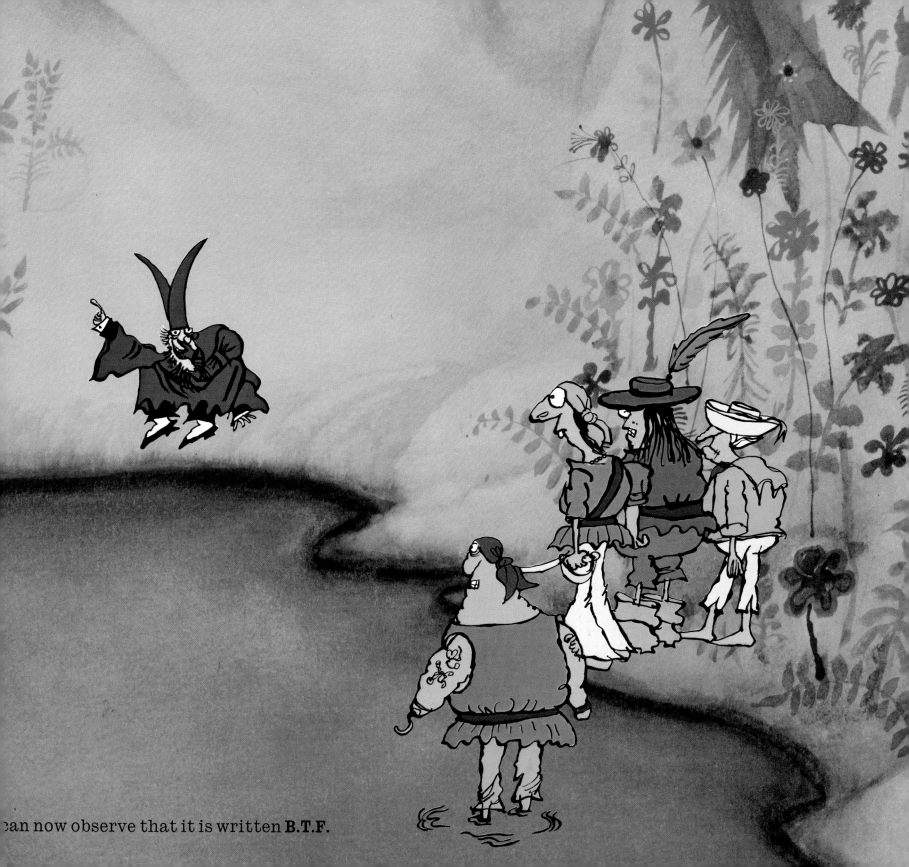

ean now observe that it is written **B.T.F.**

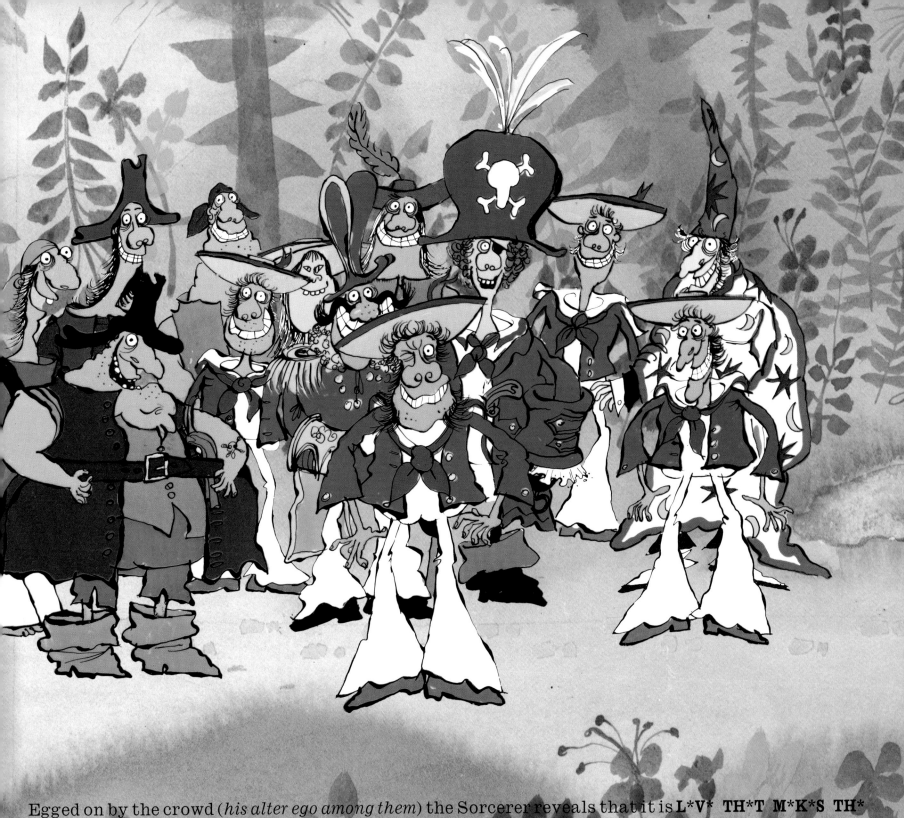

Egged on by the crowd (*his alter ego among them*) the Sorcerer reveals that it is **L*V* TH*T M*K*S TH* W*RLD G* R**ND.**

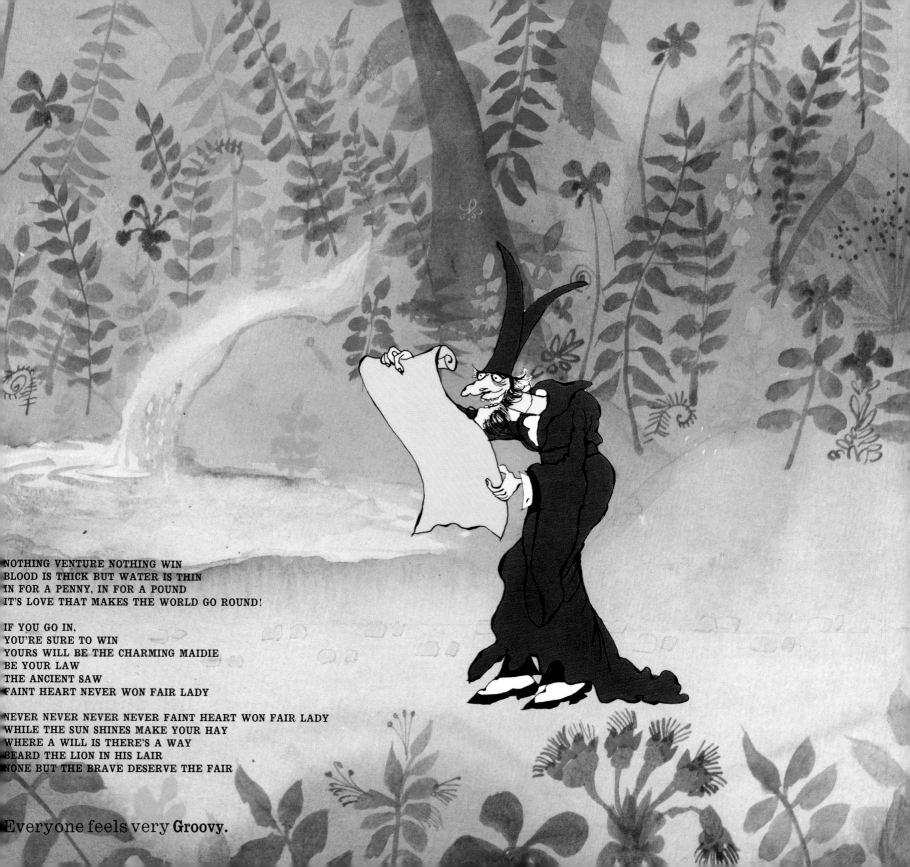

NOTHING VENTURE NOTHING WIN
BLOOD IS THICK BUT WATER IS THIN
IN FOR A PENNY, IN FOR A POUND
IT'S LOVE THAT MAKES THE WORLD GO ROUND!

IF YOU GO IN,
YOU'RE SURE TO WIN
YOURS WILL BE THE CHARMING MAIDIE
BE YOUR LAW
THE ANCIENT SAW
FAINT HEART NEVER WON FAIR LADY

NEVER NEVER NEVER NEVER FAINT HEART WON FAIR LADY
WHILE THE SUN SHINES MAKE YOUR HAY
WHERE A WILL IS THERE'S A WAY
BEARD THE LION IN HIS LAIR
NONE BUT THE BRAVE DESERVE THE FAIR

Everyone feels very **Groovy.**

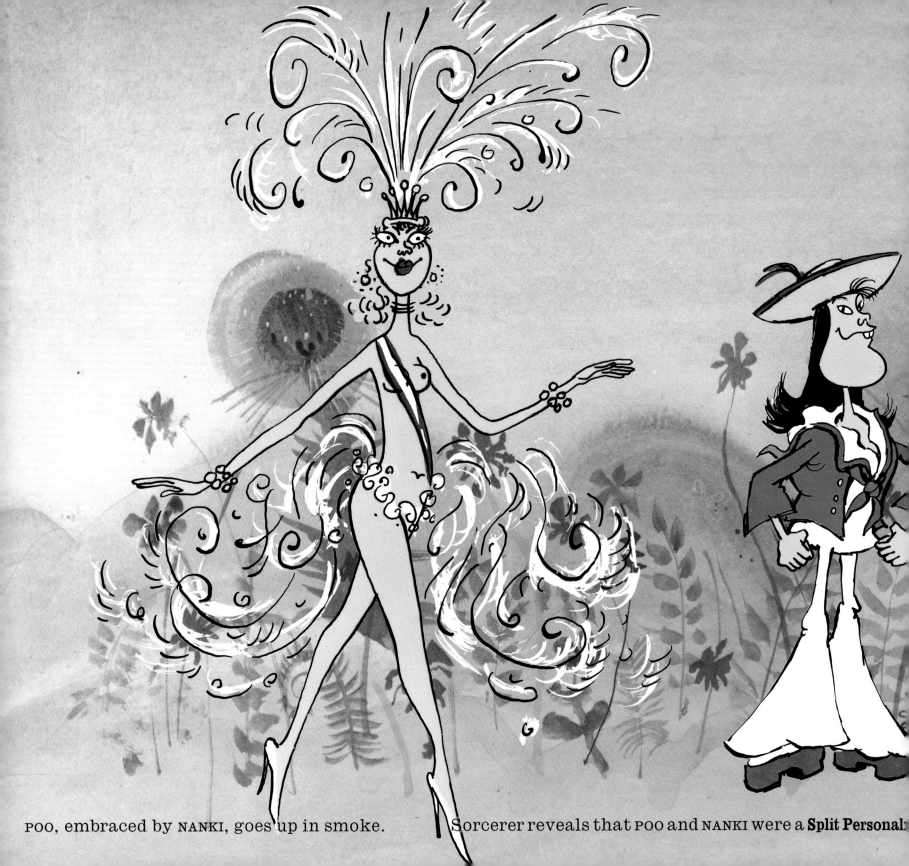

POO, embraced by NANKI, goes up in smoke. Sorcerer reveals that POO and NANKI were a **Split Personal**

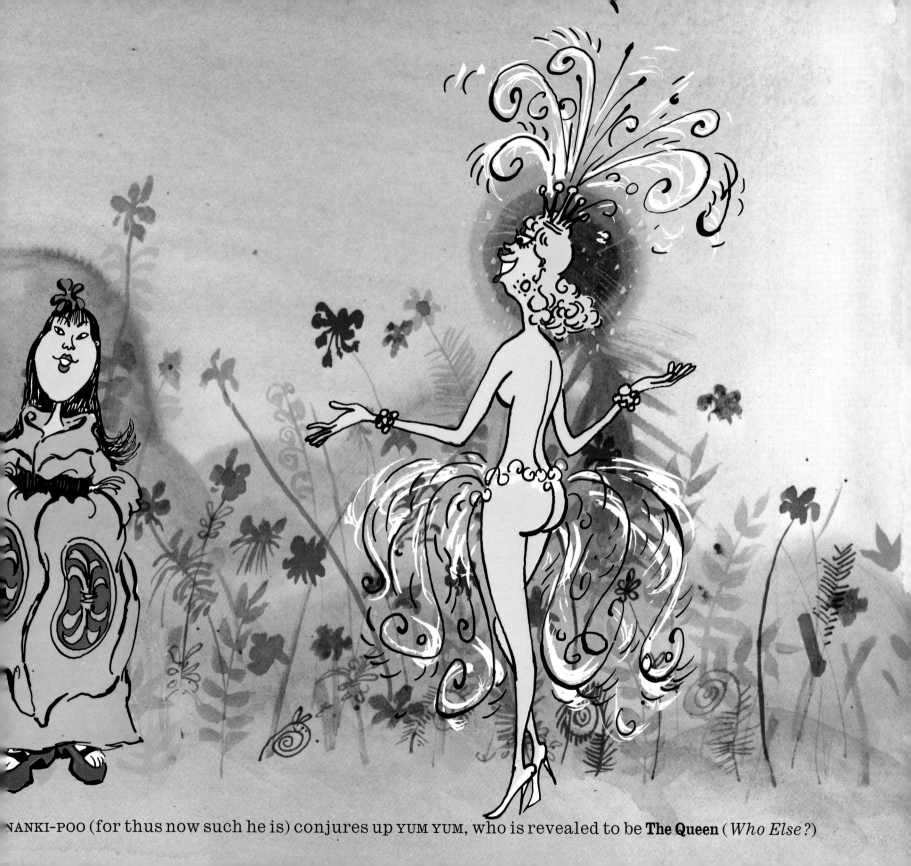

NANKI-POO (for thus now such he is) conjures up YUM YUM, who is revealed to be **The Queen** (*Who Else?*)

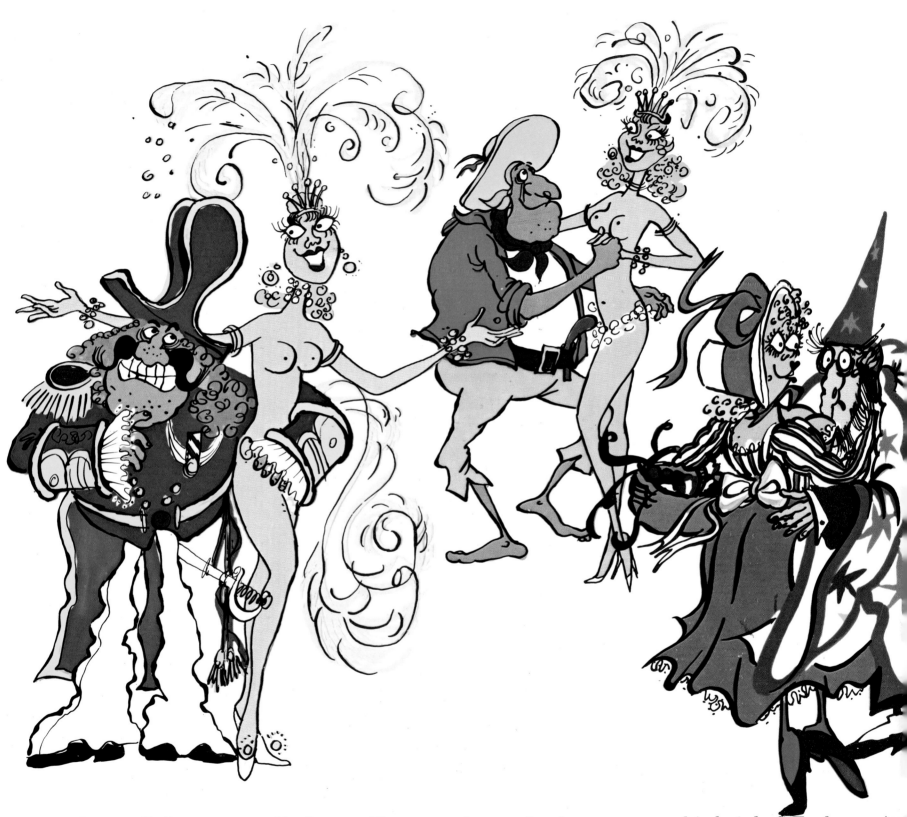

Dick grabs **Rose**. **Buttercup** grasps the **Sorcerer**. Everyone sings and swings. BELLS peal (*what else?*) Each marries

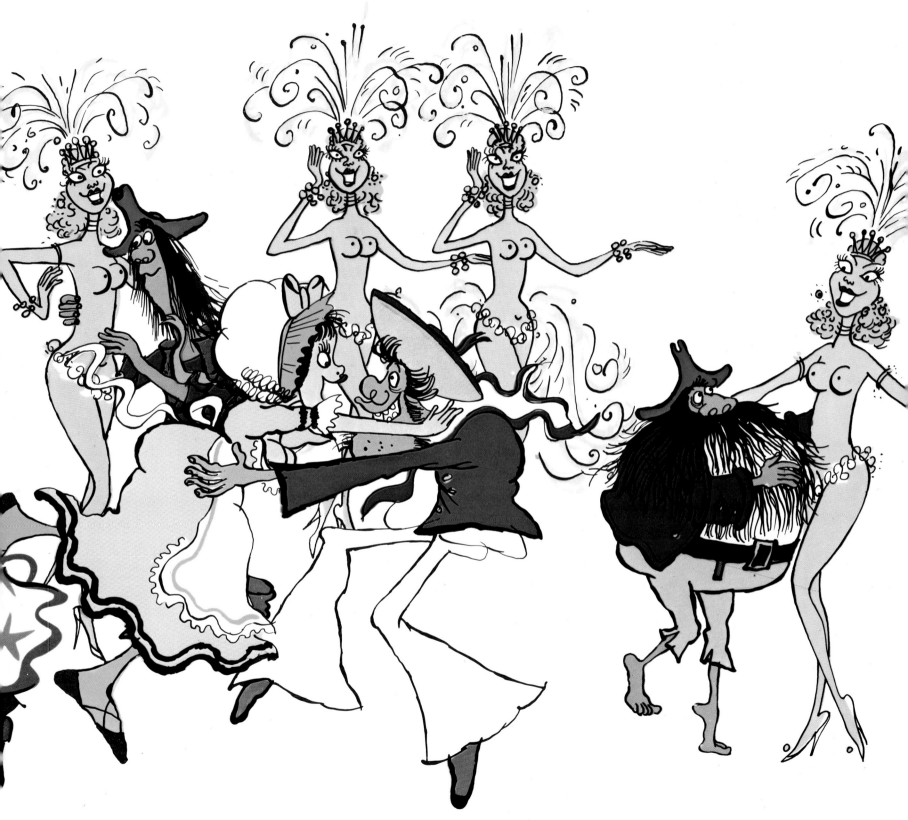

each (*whom else?*)

All in all a fittingly *gripping* climax to our tale...

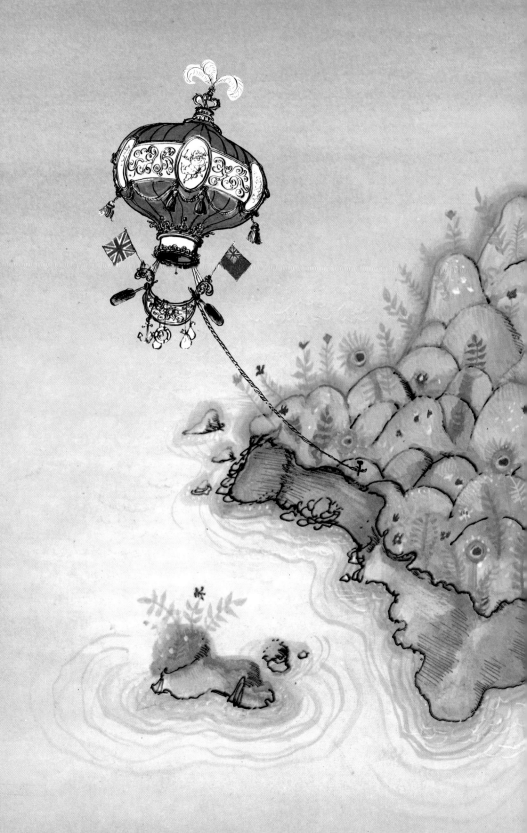

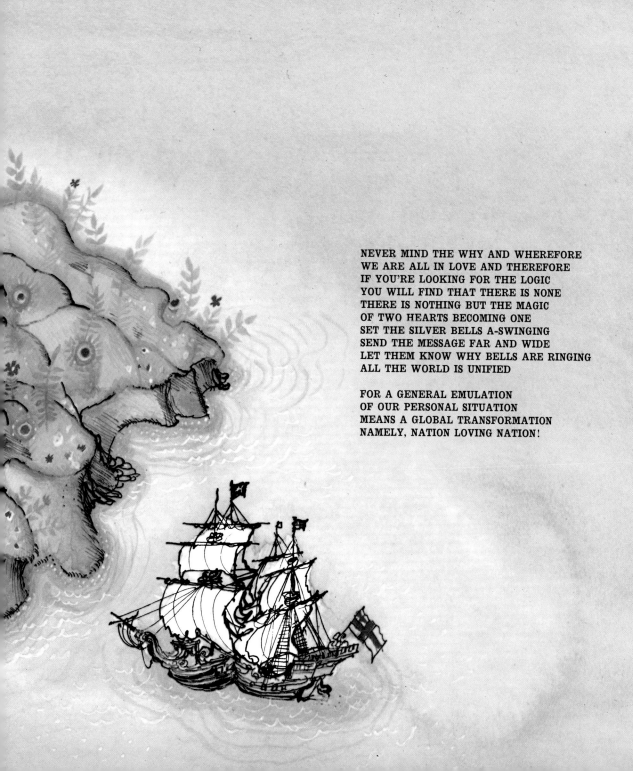

NEVER MIND THE WHY AND WHEREFORE
WE ARE ALL IN LOVE AND THEREFORE
IF YOU'RE LOOKING FOR THE LOGIC
YOU WILL FIND THAT THERE IS NONE
THERE IS NOTHING BUT THE MAGIC
OF TWO HEARTS BECOMING ONE
SET THE SILVER BELLS A-SWINGING
SEND THE MESSAGE FAR AND WIDE
LET THEM KNOW WHY BELLS ARE RINGING
ALL THE WORLD IS UNIFIED

FOR A GENERAL EMULATION
OF OUR PERSONAL SITUATION
MEANS A GLOBAL TRANSFORMATION
NAMELY, NATION LOVING NATION!

from the film

designed by : Ronald Searle
written by : Leo Rost and Robin Miller
Based on the Operas of Gilbert and Sullivan
new lyrics by : Robin Miller
music arranged and conducted by : Jimmy Horowitz
executive producer : Leo Rost
producer : Steven Cuitlahuac Melendez
director : Bill Melendez
production supervisor : Graeme Spurway
production assistant : Babette Monteil
editing : Steven C. Melendez and Babette Monteil
music producer : Ian Samwell
recording engineers : Richard Millard and John Middleton
camera : Rostrum Camera, G&M Production and Trevor Bond
animation director : Jacques Vausseur
animation/direction : Dick Horn
animators : Bill Melendez, Dick Horn, Peter Green, Mike Hibbert, Doug Jensen,
Annie O'Dell, Raphaella Lombardi, Franco Milia, Ron Coulter,
Don MacKinnon, Ann Elvin, April Spencer, Olive Scott and Tancy Baran
layout : David Elvin, Evert Brown and Gerry Capelle
backgrounds : Dean Spille and Denis Ryan
tracing and painting : Gail Hibbert, Canan Somay, Sebastien Cole, Colette Poivre
and Phyllis Vince
checking : Mike Hayes and Carol Leith
additional lyrics and arrangements : Casey Kelly